YORKSHIRE'S DINOSAUR COAST

IAN D. ROTHERHAM

AMBERLEY

Front cover photograph of Runswick Bay by Mattbuck.

First published 2014

Amberley Publishing
The Hill, Stroud
Gloucestershire, GL5 4EP

www.amberley-books.com

Copyright © Ian D. Rotherham, 2014

The right of Ian D. Rotherham to be identified as the
Author of this work has been asserted in accordance
with the Copyrights, Designs and Patents Act 1988.

ISBN 978 1 4456 1805 0 (print)
ISBN 978 1 4456 1817 3 (ebook)

British Library Cataloguing in Publication Data.
A catalogue record for this book is available from the
British Library.

Typesetting by Amberley Publishing.
Printed in the UK.

Contents

About the Author

Ian Rotherham was born in Sheffield in 1956. He is Professor of Environmental Geography and Reader in Tourism & Environmental Change at Sheffield Hallam University. He has written over 400 papers and articles, and numerous books. His research includes landscape history, the economics of landscape change, issues of invasive alien species, urban ecology, and aspects of tourism and economic development. Ian works extensively with the popular media and with grassroots, conservation groups, writes for newspapers such as the *Sheffield Star* and the *Yorkshire Post*, and has a regular phone-in on BBC Radio Sheffield. He has been visiting and researching Yorkshire's coast for over forty years.

Introduction

North Yorkshire boasts some of the most stunning countryside and amazing seaside anywhere in England. From the southern areas around Filey, Scarborough and the extensive, flat Vale of Pickering, through the rugged North York Moors, with Robin Hood's Bay, and then Whitby and Sandsend, to Staithes and northwards to Saltburn, this is Yorkshire at its best. Historically, the region was important in the early development of Christianity, and in the lower areas, it was good farming country too, so long as the floods allowed. The low-lying lands were extensive marsh, fen and carrs and the high ground of the moors was long known for the famously bleak expanses of heath and bog.

Along the coastal zones were numerous small fishing communities, with locations such as Robin Hood's Bay and Staithes growing in significance. None could match the importance of Whitby, which combined traditional fishing with a major development of whaling, as its ships set out to scour the oceans of the greatest mammals of all. From the late 1700s onwards, the region grew in importance for its health tourism with spas and then sea bathing. By the twentieth century, farming and fishing were becoming of lesser importance than holidaymaking, as thousands of people flocked to Scarborough and to the smaller resorts. The late twentieth century saw the region having evolved its tourism to include major folk music events at Whitby, the Dracula and 'Goth' themes and, of course, the long-established religious significance of the area.

The North York Moors, once a place for travellers to fear and to avoid, is now a major National Park that draws millions of visitors to the region. Here in North Yorkshire, the sea pounds the great cliffs, some of which annually tumble and fall under the assault. Beyond the clifftops are rich farming lands interspersed with ancient woods and lower-lying heaths. Then, above all, the dark, silent, sombre moors brood almost malevolently as a stark counterbalance to the ceaseless, noisy swirl of the North Sea. This is a landscape of sharp and dramatic contrasts. Wildlife, history, heritage and landscape combine to make the northern coastline of Yorkshire a dramatic place to visit. Whitby Museum holds evidence of the great sea creatures that formerly populated this region millions of years ago. Even today, as the sea inexorably erodes the soft shale rocks, fossils of remarkable sea life, from small ammonites to giant plesiosaurs, are uncovered. This is truly the 'Dinosaur Coast'.

Richly illustrated with old postcards, maps, prints, and photographs old and new, this book delves into the history, landscape, people, wildlife and nature. The North Yorkshire coast is a truly unique and remarkable meeting place for people and history, and for nature and the elements. From times immemorial to the modern day, this coastline has been a meeting place for cultures, communities and, above all, the sea.

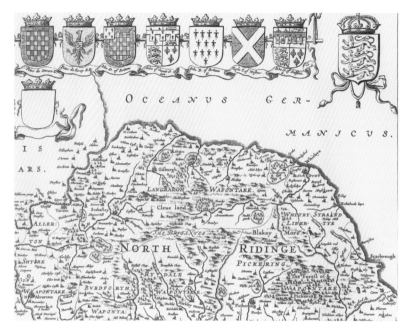

Map of North
Yorkshire, 1600s.

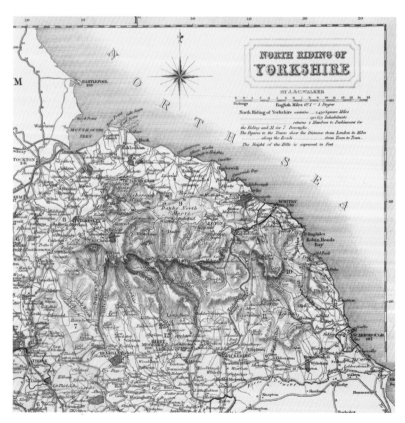

Map of North
Yorkshire in 1836.

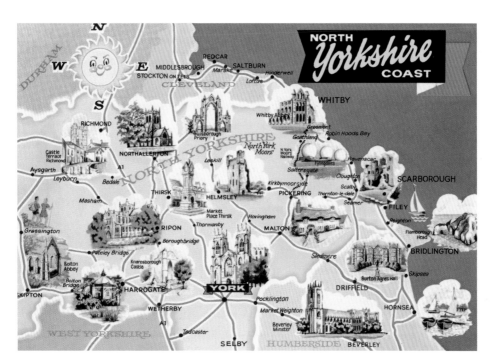

North Yorkshire Coast postcard map, 1983.

North Yorkshire Map, 1922.

The Dinosaur Coast – History, Landscape & People

This first chapter sets the scene for the region, with its unique history, the landscape and its heritage. It describes the history of the North Yorkshire coast, its countryside, and its communities, a landscape of contrasts. The moors and cliffs are dramatic reminders of raw nature. Leading to the seaside resort of Scarborough, the Vale of Pickering, now a fertile farming landscape, was once a great wetland and with people living around the water's edge. We have some of the most detailed information on the prehistoric communities that once dwelled and hunted along the shores of Lake Pickering and no doubt along the old seashore too. Today, Scarborough is one of the homes of Yorkshire cricket, but, in the past, it was an important township with a harbour, overlooked by a strategically significant castle. By the eighteenth century, the town was famous for the curative properties of its healing spa water and then of its bracing seawater cures. While the town is enjoying a renaissance in its fortunes today, old Scarborough still harks back to such time.

Further north lies Robin Hood's Bay, Whitby and Sandsend, then Staithes and, at the far north of our story, Saltburn-by-the-Sea. Each town has its own story of fishermen and fishing fleets, of smugglers and seadogs. Whitby boasts rich religious and literary heritage and lineage too. Adjacent to, and inland from these coastal settlements, are the vast expanses of the North York Moors. This unique area has its own distinctive people, places, history and heritage. Modern North Yorkshire includes the major conurbations around Whitby and Scarborough, the latter now a university town, and the more industrial areas north and inland of Saltburn. The North York Moors National Park stretches from Saltburn in the north to Helmsley in the south, and from the Cleveland Hills in the west, to the North-East Coast of England. The North York Moors National Park was designated in 1952, covering 554 square miles (1,436 square km), and is the largest expanse of heather moorland in England and Wales. Indeed, to stand on the high moorland but with a view of Whitby Abbey, the cliffs and the North Sea beyond, is an almost unique experience. The moors and sea are as one, with the cliffs and seashore joining the two elements.

Sandstone, Muds & Shale, Cliffs & Moors

The massive, flat-topped North York Moors, the shale and sandstone cliffs and the lands between the two, dominate the northern part of this region; the more southerly parts have the influence of ancient boulder clays from past glaciations. The underlying rocks determine the landform and influence man's ability to form landscapes. From Saltburn and Whitby, down to beyond Robin Hood's Bay, this is a rugged and massive landscape. In the southerly parts, from Scarborough to Filey, the countryside is tamer and with rolling landscapes dominated by intensive farming. The seashore follows a similar pattern as high, rocky cliffs and foreshore give way to eroding, lower boulder clays. The geology has also provided mineral resources and wealth, the most noticeable being the historically significant alum shales exploited from the cliffs both north and south of Whitby. Today, possible exploitation of mineral potash

from the North York Moors National Park is very controversial. Locally sourced iron ore has been processed on the North York Moors from medieval times and, in the nineteenth century, iron smelting became a booming industry and the product was shipped out from harbours like Whitby and Scarborough. Dozens of ironstone mines and several short-lived blast furnaces were constructed and, between 1856 and 1926, for example, high-grade magnetic ironstone was mined in Rosedale. A railway built around the top of the dale served the mines and the kilns constructed to process the ore. In only two decades, the population of the valley rose from 558 to nearly 3,000 people. Other minerals were exploited and, in many places across the moors, poor quality, so-called 'moor coal' was mined from the eighteenth century to the early twentieth, and in some cases was burnt mixed with locally cut peat.

Although agriculture is the main moorland occupation today, there are plenty of signs of an industrial past. There was mining for coal, jet, and iron ore and quarrying for limestone, building stone, and alum shale. The North York Moors is the only source for British jet, mined in the area from prehistoric times and the fossilised remains of an ancient relative of the Monkey Puzzle Tree. In the mid-nineteenth century, in response to the fashion for jet jewellery triggered by Queen Victoria that was focused on Whitby, the local industry grew rapidly. However, in the 1880s, cheap imports meant a decline in the industry. Another industry, which boomed and then disappeared, was the extraction and manufacture of alum. The remains of alum quarries are found in the north of the area and along the coast. Alum was important to the textile industry because it was used as a mordant or fixative for used to colour cloth. The industry thrived in the region from the early seventeenth century until 1871, the year when recently discovered chemical dyes became available. The industry collapsed almost overnight. A result of this mineral based past is that the scars of industrial activity on the moors and the coastline make the area of great interest for its industrial archaeology. It is also fascinating how many of today's prime tourism spots, once despoiled by heavy industry, are now green, pleasant landscapes.

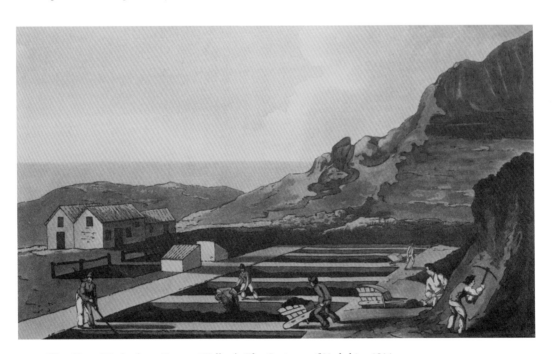

The Alum Works from George Walker's *The Costume of Yorkshire*, 1814.

The North York Moors consist of a huge moorland plateau, intersected by deep valleys or dales with farmland and woodland. The largest dale is Eskdale, the valley of the River Esk that flows from west to east, which discharges into the North Sea at Whitby. The Cleveland Hills rise north of Eskdale and at the western end of the valley, where it divides into three smaller dales: Westerdale (the upper valley of the River Esk), Baysdale and Commondale. Other side dales drain into Eskdale from the moors on the southern flank, from west to east: Danby Dale, Little Fryup Dale, Great Fryup Dale, Glaisdale and the Goathland Valley. Kildale, west of Commondale, separated only by a low watershed, is drained by the River Leven, which flows west to the River Tees and out to the North Sea near Middlesbrough.

On their south side, the moors are marked out by a series of dales draining into tributaries of the River Derwent. Beyond the westernmost dale, Rye Dale, and its offshoot, Bilsdale, are the Hambleton Hills. East of Bilsdale, cutting into the moors and gradually closing on the coastline are Bransdale, Farndale, Rosedale, and Newton Dale. In the south-east of the Moors, the landscape is marked by the narrow valleys of the higher reaches of the Derwent and its upper tributaries. The River Derwent, which begins its life so close to the coastline, crosses the Vale of Pickering flowing westwards, turning southwards at Malton and flowing through the eastern part of the Vale of York before emptying into the River Ouse at Barmby-on-the-Marsh.

Rocks of the Jurassic Period, mostly laid down in subtropical seas 205 to 142 million years ago, dominate the geology of the North York Moors. Fluctuations in sea level produced different rock types varying from shales to sandstones, and limestones derived from coral. From Staithes to Filey, the rocks of these marine and deltaic deposits are superbly exposed on the Yorkshire coast.

Lower Jurassic: At the beginning of the Jurassic Period, shales, clays, thin limestones and sandstones were deposited in a tropical shallow sea. These deposits are many metres deep and include layers of ironstone of various thicknesses and the shale rocks from which alum was extracted.

Middle Jurassic: A period of gradual uplift happened, with mudstones and sandstones deposited on a low-lying coastal plain crossed by large rivers. Occasionally this land was inundated by the sea, and the result was deposition of the Ravenscar Group of rocks – calcareous stone containing typical marine fossils. Oxford Clay was laid down at the end of this era.

Upper Jurassic: Towards the end of the Jurassic Period, the land was again below sea level and was inundated. Originally, the sea was shallow, with calcareous sandstones and limestones deposited, along with the corallian rocks of the Tabular Hills found towards the south of the area. Overlying the corallian rocks is the Kimmeridge Clay, which underlies the Vale of Pickering, but is not exposed at the surface.

Subsequently, about 30 million years ago, earth movements uplifted and tilted the land towards the south. As the upper layers of rocks eroded, older formations were exposed in places. With the tilting from the Earth's movement, the oldest rocks were exposed in the north, and bands of shales and ironstones on the northern scarp of the moors and Cleveland Hills. The middle layers are the sandstones of the high moors and the youngest are the Tabular Hills limestones. In the dales, like Rosedale, where the rivers have cut through younger rocks, there are exposures of older shales, ironstone and sandstone.

During the Quaternary Period (the last 2 million years), the North Yorkshire landscape was subject to a series of glaciations. The most recent glaciation, the Devensian, ended about 11,000 to 14,000 years ago. However, the higher parts of the North York Moors stood proud

and were not covered by the ice sheets. The higher ground was subjected to intense freezing conditions and glaciers flowed southwards on either side of the land mass.

Then, as the climate warmed at the end of the last glaciation, the snowfields on the moors began to melt and the permafrost thawed. Unable to escape northwards, westwards, or eastwards because its route was blocked by ice, the meltwater was forced southwards. Huge torrents of water from the Esk valley flowed south to gouge out the deep Newtondale Valley. Water from the moors formed a vast lake in the area of the Vale of Pickering – the prehistoric 'Lake Pickering'. Eventually, as water poured in, the lake filled its basin and then overflowed at the lowest point, which was at Kirkham, the steep-sided Kirkham Gorge. As the ice finally melted and the ice sheets retreated, they left behind deep deposits of boulder clay (or 'till'). Significant for today's landscape, the boulder clay blocked the eastern end of the Vale of Pickering, resulting in a permanent deviation in the course of the River Derwent (south towards York). Another significant feature in the modern landscape is that alluvium from the glacial meltwater covered many areas to the north of the Moors, in the Esk Valley, and along the coastline.

The corallian limestone belt, on the lower, south-facing slopes of the North York Moors, is a thin belt of corallian limestone, which outcrops from west to east and is found just inland of Scarborough. The rock weathers easily to produce nutrient-rich alkaline soils on well drained rocks. Gouging by glacial meltwaters has left spectacular valleys along whose floors run attractive streams.

A Wild Heritage Coast
A stunning contribution of geology to the North Yorkshire landscape is the 26-mile heritage coastline of the North York Moors National Park, a spectacular monument with towering cliffs. These reach up to 650 feet or 200 metres at Boulby, the highest point on the English East Coast. Walkers enjoy the stunning views from the Cleveland Way National Trail that runs the entire length of the North York Moors National Park coastline and beyond. Starting at Helmsley and skirting the North York Moors, in 1969, it was the second National Trail to be opened.

From Moorland & Bog, to Oak Woodland Flowers and Clifftop Seabirds
This northern region is a mix of contrasting acidic, peat-rich pools and streams, and limestone streams with nutrient-rich waters, which support an abundance of aquatic invertebrates such as insect larvae and crustaceans. In turn, the latter support fish like trout and grayling. Rich in insects that emerge from the river waters in summer, these provide a rich source of food for birds. Typical birds along the fast-flowing streams and rivers are grey wagtails, dippers, kingfishers, swallows and spotted flycatchers. Grey herons, almost prehistoric in their languid heavy flight, are also typical. Water voles thrive here and otters have returned to recolonise the rivers and streams. Badgers do well around the moorland fringe, fallow deer are found and roe deer are increasingly.

Sessile Oaks dominate sheltered woodlands away from the high ground, including along the sea cliffs. In summer, these woods are home to pied flycatchers, blackcaps, common redstarts, and wood warblers. Sparrowhawks, common buzzard, and kestrel are widespread. fallow deer are also found here. The woodlands, heaths and south facing grasslands, especially on the limestone, provide a good habitat for many butterflies. Inland, Farndale is famous for its springtime wild daffodils, but, along the seashore clifftops, the vegetation is especially rich with bluebells, wood anemones, primroses and other wildflowers. The fertile alkaline or limey soils of the limestone belt and the clifftops support an abundant flora. Here, hedgerows and scrub have plentiful flowers and ferns in spring through to summer, and butterflies and other insects follow. The limestone grasslands and calcareous flower meadows on the cliffs support a wide variety of wildflowers, with rarer

butterflies such as pearl-bordered Fritillary, Duke of Burgundy fritillary, marbled white, dingy skipper, and grayling. Rarer plants such as the wood vetch and various orchids are also found. Interesting fauna in suitable habitats across this region includes adders, widespread throughout the National Park, with Common Lizards among their prey.

A Land of History, Heritage & Fisher Folk Communities
The North Yorkshire Moors and the nearby coastline have been inhabited since early prehistoric times. Evidence of this, such as the remains of ancient burial chambers, standing stones, forts, stone crosses, field patterns and settlement sites, is present throughout the region. During Roman times, the region was extensively settled, with features such as Wade's Causeway, a mile-long, first-century Roman road found on Wheeldale bearing testimony to a long-standing occupation. However, many early sites are along the coastline, on rocky promontories and high ground, with security and good visibility. These are the locations with evidence of early occupation and of the earliest Christian sites.

Later occupation and land use are evidenced by the ruins of great Yorkshire monastic houses such as Rievaulx, and numerous old castles such as at Scarborough and Pickering. Furthermore, many fine, listed buildings provide archaeological and historical interest throughout the region. Where sites have been spared by the tractor-driven plough of twentieth-century intensive agriculture, ancient settlements are to be seen, and on the clifftops or nearby fields are medieval ridge and furrow systems, medieval tracks and lanes, and ancient hedgerows. Early Norman churches and later medieval villages mark old, established settlements throughout the landscape.

The coastal settlements like Robin Hood's Bay were traditionally associated with fishing and smuggling, and the larger towns of Scarborough and Whitby were ports and trading centres. Whitby in particular was famed for its role in the whaling industry of the 1700s and 1800s. Throughout the medieval and early industrial periods, sailing ships called colliers hauled 'sea coal' up and down the coastline.

Today, farmers and private landowners, who manage the land for grouse shooting and sheep, own most of the North York Moors National Park. On slopes and lower ground, sheep and cattle graze fields surrounded by drystone walls or neat enclosure hedgerows that are typical of the North Yorkshire Moors. The rural communities are dispersed in farmsteads, tiny hamlets, and small villages. On a dark winter night, with the blackest of skies, the landscape is dotted with lights of scattered farms and cottages across dale-side and clifftop.

The seaside communities are also much more cosmopolitan, with still some links to the fishing and farming industries, but overall a much diversified profile. Over the last two centuries, a large proportion of the local populace has been connected directly or indirectly with tourism and holidaymakers. With burgeoning tourism trade, there was a growth from the late 1800s and through the 1900s of the small bed and breakfast establishments in all the resorts. These mostly provided low-cost accommodation and were often run by famously authoritarian landladies. Supporting service industries also grew, with cheaper restaurants, takeaway outlets – especially the ubiquitous fish and chips – and, of course, the pleasure parks and amusement arcades. As the more popular tourism took off, the fashionable pleasure seekers began to move elsewhere.

However, from the 1970s onwards there was a decline in the typical British holiday market as people flocked to cheap overseas destinations. Since then, some resorts have struggled to adapt, but others have diversified and evolved to provide for new demands and growing fashions for short breaks and specialist holidays. Towns such as Scarborough and Whitby are enjoying an economic renaissance, supported by people relocating to homes by the seaside, to second homes, and by the 'grey pound', as older people retire to the seaside resorts.

The Harbour and Oliver's
Mount, Scarborough,
early 1900s.

The harbour at
Scarborough, early 1900s.

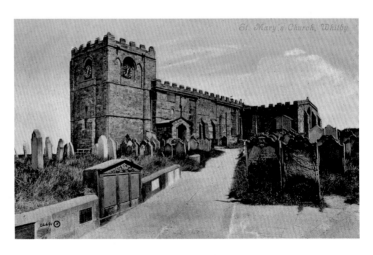

St Mary's church,
Whitby, 1912.

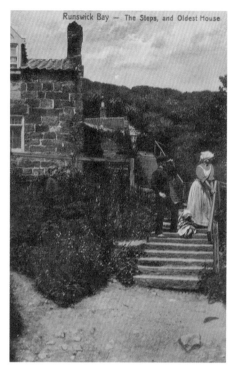

Left: Runswick Bay – the steps and the oldest house.

Below: Scarborough Pierrots, 1906.

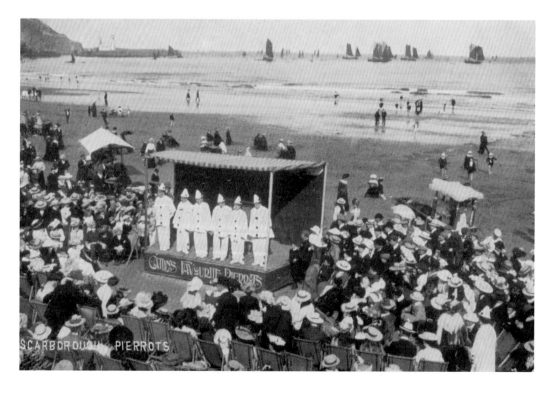

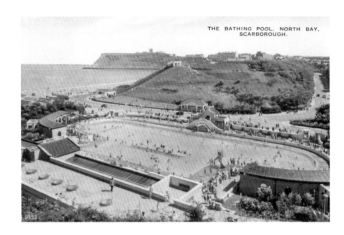

The Bathing Pool, North Bay, Scarborough, 1952.

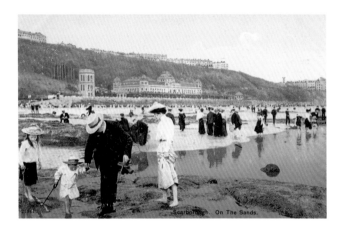

On the sands at Scarborough, early 1900s.

East Coast, 'It's Quicker By Rail', 1933.

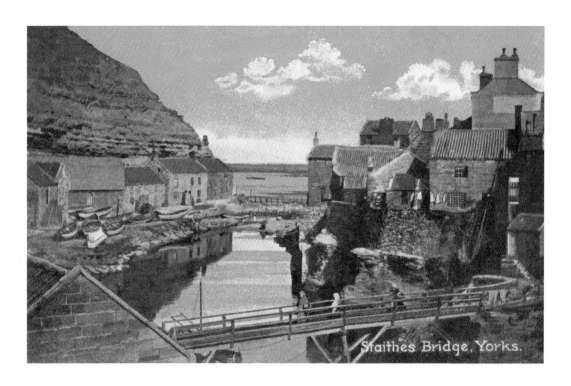

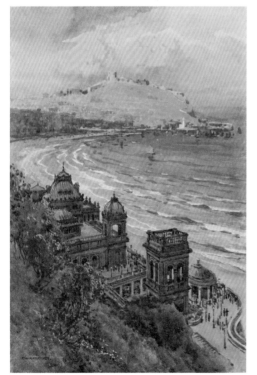

Above: Staithes Bridge, early 1900s.

Left: The Spa and South Bay Scarborough, early 1900s.

The Southern Dinosaur Coast –
From Filey to Scarborough

The southern landscape is dominated by low cliffs of boulder clay into which the seaside resort of Filey nestles. The history of tourism and holidaying in North Yorkshire, the Moors, and its seaside is one of a dramatic rise and then a successful adaptation to new challenges. Cultural tourism to Whitby and the leisure visitors to the North York Moors National Park have grown, but, in recent decades, mass tourism to Scarborough and Filey declined. North Yorkshire remains a hugely success tourism destination with remarkable picturesque landscapes and seascapes. Farming, fishing and forestry are still important, and there are numerous great landed estates still very much intact at the core of the local scene. Along the coastline, tourists are more important to the economy than the small fishing boats, but the latter are still a part of the images that draws the visitors to the region. The tourism industries in Filey and Scarborough are now enjoying something of a renaissance, and the latter, now a thriving university town as well, has turned a corner. Between Scarborough and Filey are the tiny settlements of Osgodby, Cayton Bay (with its holiday camp) and Gristhorpe (with the nearby caravan site). To the south are major holiday camp and caravan sites at Primrose Valley and Reighton Gap, and a modern housing development at Hunmanby Gap. Bempton and Flamborough are south of these.

Surrounded by breathtaking scenery and beautiful landscapes, the bustling village of Hunmanby is on the edge of the Yorkshire Wolds, about 3 miles south-east of Filey and 9 miles from Scarborough. From the 1800s until 1960, brick making was one of the local industries, and many of the buildings are made from these 'home-produced' bricks. A number of buildings in the village are from the seventeenth century, the oldest (apart from the parish church) being the Manor House. With Saxon carvings from around AD 900 in the north wall, the early Norman church of All Saints is on the main street. The village has a small street of shops, two public houses and a market place cross.

Muston is a delightful village situated about 2 miles southwest of Filey, with a 'Conservation area' and numerous listed buildings. This sleepy, picturesque village is lined with country cottages, beautiful gardens and a quaint community church. Most of the houses date from the eighteenth and nineteenth centuries (the oldest built about 1724), and are constructed of a mix of local brick, chalk, and stone brought from north of Filey. There were two inns, but the Cross Keys built in 1755, now a private residence, closed in the 1960s. The Ship continues as the village pub. Rebuilt in Early English style in 1863, All Saints church is on the site of an earlier building. Muston Hall, with its fine gardens, built in the early nineteenth century, is in the centre of the village set back from the road. This village has a now famous annual scarecrow festival.

On the outskirts of Scarborough going towards Filey, is Osgodby village, a pretty settlement with a village pub, local store and community centre. Gristhorpe village is about 2 miles inland from Filey.

Filey

Historically part of the Yorkshire East Riding, Filey is a small town and civil parish and, today, is located between Scarborough and Bridlington on the North Sea coast, part of the borough of Scarborough. Although it was a fishing village, it has a large beach and became a popular tourist resort. According to the 2011 UK census, Filey had grown to around 7,000 residents. The town forms the eastern end of the Cleveland Way, and is at the northern end of the Yorkshire Wolds Way National Trail. The latter begins at Hessle and crosses the Yorkshire Wolds. Apparently becoming an epicentre for trails and long-distance routes, Filey is also the finishing point for 70-mile (110-km) Great Yorkshire Bike Ride from Wetherby Racecourse.

This seaside resort has a long history, beginning in the late fourth century, when the Romans built a signal station on Carr Naze where the soldiers could watch for Saxon raiders. The first excavations of the site were 1857, and the base stones of the buildings were found. In 1993, the York Archaeological Trust and English Heritage carried out further excavations that were more extensive, and these are reported on interpretation boards at the site. Filey's name indicates Anglo-Saxon origins and a community here for about twelve centuries. The name could be derived from 'Five Leys', meaning meadows or clearings in a wooded landscape. 'File' relates to a slip of land thrust out into the sea, i.e. the Brigg. However, the name might be from Roman, Porto Felix, a port on the Yorkshire coast, and the remains of an ancient quay or pier have been found close to the inner part of the Filey Brigg – 'brigg' meaning a jetty or quay. Indicating the importance of the area and its strategic significance for a county under an increased threat of sea raiders, remains of Roman roads from inland York have been found close to Filey and Hunmanby.

The Filey Parish Church, dedicated to St Oswald, is on land given by Walter de Gant to the Prior of Bridlington. Norman and Early English in style, with a low, broad tower rising from the intersection of the transepts, construction began around AD 1180 and was completed in 1230. An interesting touch of local and social history is the story of the 'Boy Bishops'. On the south wall of the Filey church nave is a carved figure from between 1250 and 1300, of a boy bishop who died in his year of office. Boy bishops were elected by the boys of the parish from their peers to be their leader, performing the office of a miniature bishop, from St Nicholas Day (6 December) to Christmas Eve. Apart from St Oswald's church, the oldest building is Filey Museum on Queen Street, built in 1696. In 1931, the Dogger Bank earthquake damaged a church spire in Filey.

Filey and its church have strong literary traditions and, in one of the letters to her sister Emily, Charlotte Brontë commented on the congregation with their backs to the organ and choir. The organ and choir stalls used to be at the west end of the church, but, in 1908, the organ was completely burned out and it was only by providence that the church was saved by a willing band of workers. In 1974, the organ was completely overhauled. The inside of the church was partly restored in 1839, but it was in a poor state when Canon A. Cooper, the so-called 'Walking Parson' became Vicar of Filey in 1880. Canon Cooper wrote many books on his walks abroad, retiring in 1935 after being Vicar of Filey for fifty-five years, the longest on record for the parish. The next vicar only managed eighteen months and was the shortest on record.

For most of its long history, Filey was a fishing and farming village, with just a few hundred people living as a close-knit community along a street now called Queen Street. It is known from ecclesiastical records that, as early as the twelfth century, Filey fishermen were going as far away as Whitby, Hartlepool to the north or Grimsby to the south. Fishing and coastal farming remained at the heart of this small settlement of local seafarers. Filey was a small village until the eighteenth century when, as an overspill from Scarborough's success and consequent hustle and bustle, visitors came to Filey for peace and quiet. These early tourists stayed in local inns or people's houses, until the early nineteenth century, when Foords Hotel opened, the first house in Filey actually

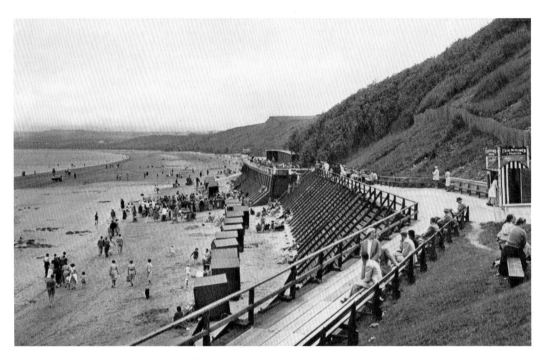

Filey Chidren Corner, early 1950s.

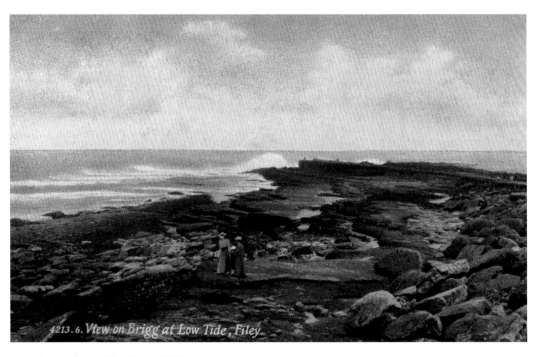

Low tide on Filey Brigg, 1908.

built for visitors. Fashionability soon followed. In 1835, a Birmingham solicitor called John Wilkes Unett bought 7 acres of land to construct The Crescent, which opened in the 1850s. Later known as the Royal Crescent, its reputation grew to become a highly desirable address at which to reside. As a boy, the renowned English composer Fredrick Delius stayed with his family on The Crescent at Miss Hurd's boarding house, No. 24, in 1876 and in 1877. He returned but to Mrs Colley's at No. 24 in 1897.

To serve the burgeoning tourist trade, the railway reached Filey in 1846 to 1847. The Seamer to Filey line opened in 1846, and, creating a route to Hull, the Filey to Bridlington line in 1847. Today, Filey has a railway station on the Yorkshire Coast Line and a second at Filey Holiday Camp, south of the town and serving firstly the former Butlin's Holiday Camp, and now The Bay, Filey.

At seaside resorts, entertainment was tremendously important, and Filey was no exception to this. In Victorian and Edwardian times, small groups of musicians played in the gardens during the summer season, a tradition that continued into the 1950s. Having lapsed for many years, Filey Town Council has revived the annual performances with brass bands, and silver bands playing during the summer months on Sunday afternoons. During the 1950s and 1960s – the post-war boom years – the Filey Butlin's Holiday Camp expanded to become a key factor in Filey's tourism economy. In fact, the site was already beginning in 1939 and during the war years was a military base known as RAF Hunmanby Moor. Perhaps this followed the establishment, in 1910 to 1912, of the Filey Flying School on the nearby cliffs between Primrose Valley and Hunmanby Gap. However, when the conflicts ended in 1945, the camp became a popular holiday resort, complete with its own railway station to bring the masses from the industrial cities of northern England. An address at The Crescent was now somewhat less fashionable, but Filey was a small boomtown. By the late 1950s, Butlin's at Filey could accommodate 10,000 holidaymakers. Sadly, this was its zenith, and like so many East Coast resorts, Filey lost out to the new fashion for cheap, overseas holiday travel,

The Crescent Filey, 1905.

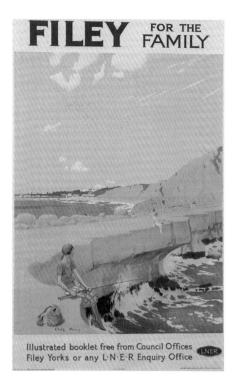

Right: Filey For The Family LNER publicity poster with woman fishing off Filey Brigg, published 1920s.

Below: Filey, 1905.

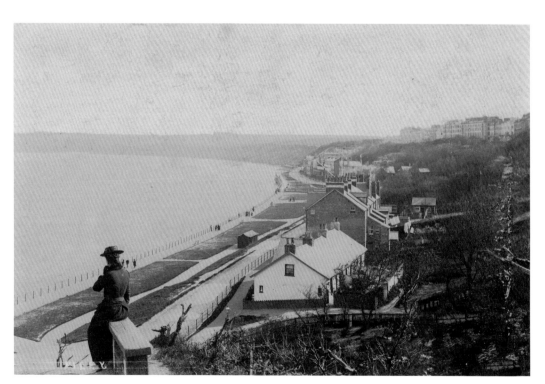

and the rest, as they say, is history. Butlins, now somewhat out of date and dilapidated, closed in 1984, causing a sharp decline in the tourist holidaymakers to Filey.

However, the tide is turning as it always does, and the camp, now modernised and a bit more up market, has been redeveloped as 'The Bay' at Filey. With the first homes completed in 2007, this 600-home holiday housing development is one of the largest coastal developments of its kind in the UK.

Scarborough was historically in North Riding of Yorkshire, and rises from sea level, quite sharply to around 230 feet (70 m) above sea level, rising steeply northward and westward from the harbour onto the limestone cliffs. The older part of the town, overlooked by the historic castle, lies around the harbour and protected by a dramatic, rocky headland.

Having a population of around 50,000 and now a university campus too, Scarborough is the biggest of these East Coast towns and the largest holiday resort on the Yorkshire coast. Today, Scarborough has fishing and service industries, and a growing sector in digital and creative activities. These are along with its importance as a tourist and day-trip destination. The location is quite stunning, and the most striking feature of the town's setting is a high, rocky promontory jutting eastwards into the North Sea. On this headland, separating the sea front into two bays, to the north and south, stand the ruins of the eleventh-century Scarborough Castle.

The early medieval settlement was originally around the South Bay and, together with the harbour, forms the current 'old town district'. Even today, this is the main tourist area, with a beautiful sandy beach, cafés, amusement arcades, theatres and other entertainment facilities. The modern commercial centre of the town has moved about a quarter of a mile north-west of the harbour, and about 100 feet (30 m) upslope with the transport facilities, services, shops, restaurants, pubs and nightclubs. Recent redevelopment around the harbour

Butlin's, Filey, 1974.

The beach at Butlin's, Filey. 1970s.

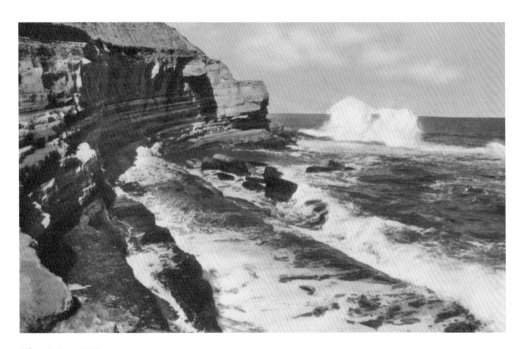

Filey Brigg, 1920s.

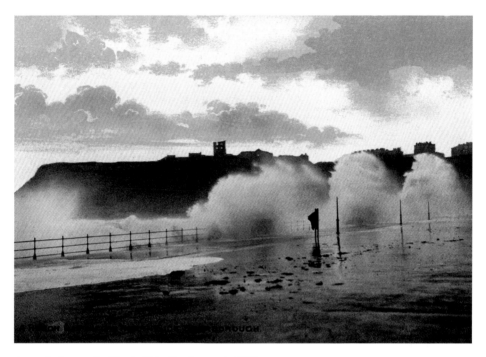

A rough day on the North Side, Scarborough, 1909.

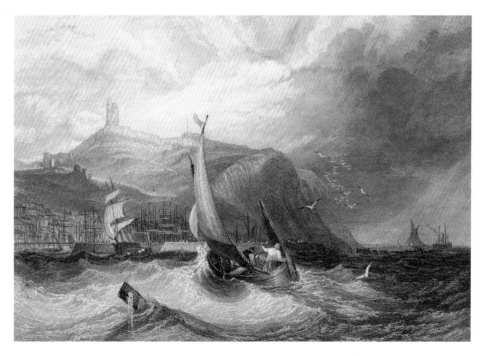

Boats and stormy waters off Scarborough Castle, early 1800s.

included major regeneration to include the Albert Strange Pontoons, improvements in terms of a pedestrian-friendly promenade, better street lighting, and street furniture. The Stephen Joseph Theatre has an excellent reputation, and for those curious to know more of the town's history, the Scarborough Maritime Heritage Centre will hit the spot.

The North Bay is the less commercial and more peaceful area of the resort. Peasholm Park was restored to its Japanese glory in June 2007. This includes a reconstructed pagoda and, throughout the summer holiday season, a mock maritime battle re-enactment. The latter is based on the Battle of the River Plate, but on the boating lake and with large model boats and fireworks. Further north is the Scarborough Sea Life Sanctuary, and from the park, through Northstead Manor Gardens, runs a miniature railway to the Sea Life Centre at Scalby Mills. With Neptune was built in 1931 by Hudswell Clarke of Leeds, the North Bay Railway claims to have the oldest operational diesel hydraulic locomotive in the world. Until closing in 2000, Marvel's Amusement Park was on the hill behind Atlantis and reached by cable car. The pylons still stand but the site is now derelict, and the roller coasters and other rides have moved elsewhere. However, Northstead Manor Gardens still hosts the North Bay Railway, and has other attractions during the summer season like the Open Air Theatre, the water chute, and the boating lake with boats for hire. The Lord Mayor of London originally opened the theatre in 1932 with audiences flocking to see 'Merrie England', the first production staged at this outdoor venue; on Yorkshire's East Coast, even in summer this is a brave undertaking. However, regular summer season productions were staged every year until the

Scarborough Castle from Leyland, 1892.

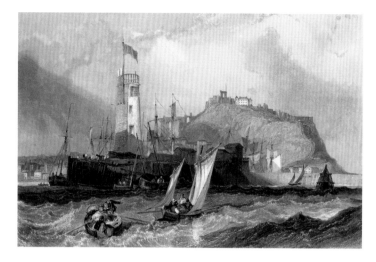

Scarborough Castle, Lighthouse and boats early 1800s.

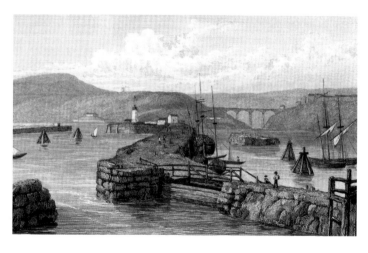

Scarborough Pier, 1830.

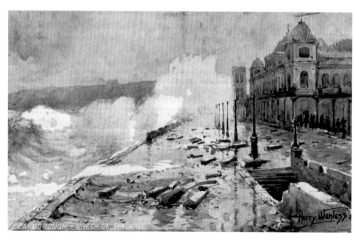

Scarborough wreck of the Spa wall, 1906.

musicals ended in 1968; the last showing was *West Side Story*. Scarborough was suffering from changing holiday patterns and competition from low-cost overseas travel, numbers eventually fell. By 1977, the shows had stopped apart from a YMCA production in 1982, and with the stage-set building on the island demolished and the dressing rooms dismantled, the seating was removed. Concerts were still held until 1986, the final one being, appropriately, by James Last and his orchestra. Nevertheless, the show must go on, and Scarborough's Open Air Theatre reopened on Friday 23 July 2010. This was a spectacular operatic concert with José Carreras and Dame Kiri Te Kanawa, accompanied by the Opera North Orchestra, and a firework display finale. The Open Air Theatre, now the largest such venue in Europe, is testimony to Scarborough's continuing appeal and its twenty-first-century renaissance. The Marine Drive is an extensive Victorian promenade, constructed around the base of the headland and linking North Bay and South Bay, both with popular sandy beaches and, at low tide, numerous rock pools around the headland. Scarborough Castle, a spectacular sentinel, proudly overlooks both bays, as it has done for nearly a thousand years. The castle last saw active service in the First World War, when the German warships SMS *Derfflinger* and SMS *Von der Tann* bombarded it.

Situated above the Spa and South Cliff Gardens, South Cliff Promenade commands excellent views of the South Bay and old town. From the heyday of Scarborough's time as the fashionable spa destination, the splendid Regency and Victorian terraces are still intact. Nowadays, these form a mix of quality hotels and holiday apartments. The ITV television drama *The Royal*, that ran from 2003 to 2011, and its more recent spin-off series, *The Royal Today*, were both filmed here. *The Royal* was itself a spin-off from the hugely popular British series *Heartbeat*, a police drama set in the 1960s North Riding of Yorkshire. Made by ITV Studios (formerly Yorkshire Television) at the Leeds studios and on location, *Heartbeat* was broadcast on ITV in eighteen series between 1992 and 2010. It was first aired

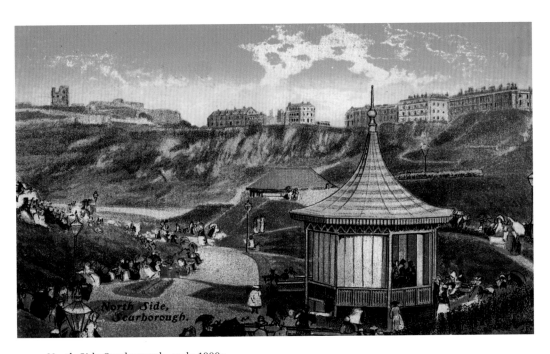

North Side Scarborough, early 1900s.

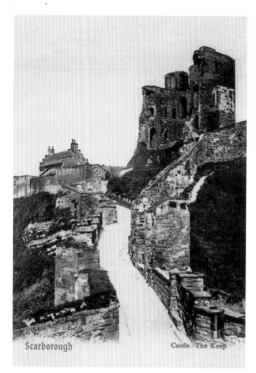

Left: The Keep, Scarborough Castle, 1903.

Below: Italian Terrace Garden on the Spa at Scarborough, 1921.

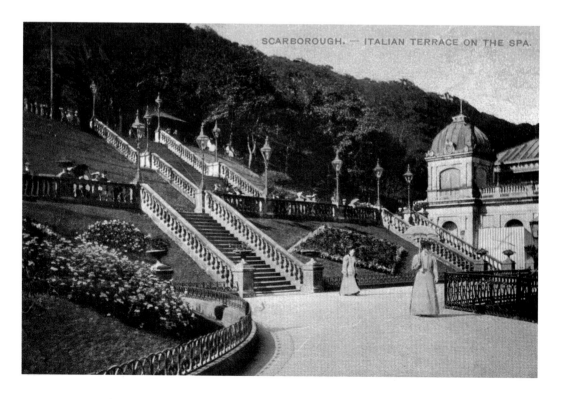

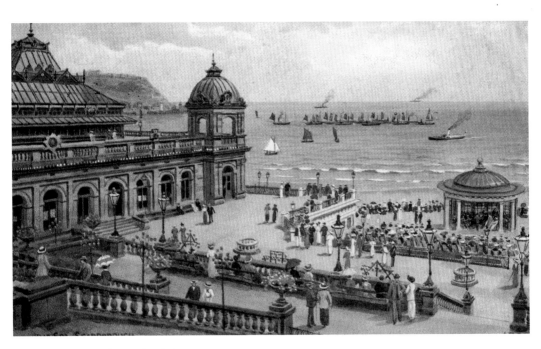

The Spa, Scarborough, 1914.

on Friday 10 April 1992, later moving to Sunday evenings, and the final (372nd) episode went out on Sunday 12 September 2010. The impact of the programme that regularly topped 10 million viewers on the region's tourism, plus syndicated and repeat viewings, is incalculable. The Scarborough-based follow-up is just one more example of how artists, writers and filmmakers are drawn to the landscape and the charm of the Yorkshire coast and its communities. Other films featuring Scarborough settings include films *Little Voice, Possession, A Chorus of Disapproval, Miranda, Dancing Queen, Beltenbros, The Brides in the Bath* and *The Damned United*.

Surprisingly, but associated with North Yorkshire dark skies, Scarborough has an active astronomical society and a field observation station at Dalby Forest. Overlooking the South Bay is the largest illuminated 'star disk' anywhere in the UK; 85 feet (26 m) across with forty-two that glow at night as fibre-optic light points. These show the brightest stars always visible in the northern sky above Scarborough's distinctive headland, with the Pole Star almost at the centre, and the other well-known constellations around it.

Scarborough is well provided with parks and gardens, and south-west of the town, beside the York railway line, is an ornamental lake known as Scarborough Mere. This began its history as a medieval peat cut and one of the sites, which provided essential fuel to heat the buildings of the ancient settlement. Then, during the twentieth century, the Mere was a popular park, with rowing boats, canoes and a miniature pirate ship, the *Hispaniola* that took passengers to 'Treasure Island' to dig for doubloons. The *Hispaniola* was built at the specific request of the then Scarborough Corporation, a unique creation based on descriptions and images in Robert Louis Stevenson's *Treasure Island*. The resulting boat has two decks, three masts and twenty-six gun ports (sadly without guns). It is small, about a quarter of the size of a real schooner, but still popular with amateur filmmakers as an authentic prop for seafaring adventure stories. The boat ventures far

Guide to the Royal Hotel, Scarborough.

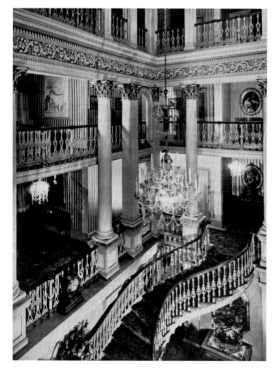

The staircase in the Entrance Hall at The
Royal Hotel, Scarborough, in the 1960s.

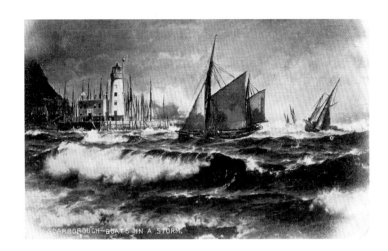

Boats in a storm,
Scarborough, 1904.

Broadstairs York Gate,
Scarborough, early 1900s.

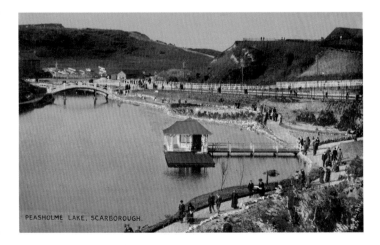

Peasholme Lake,
Scarborough, 1912.

and wide, making appearances in Whitby in the 2000s and as far away as Morecambe in the 1970s.

Gradually the Mere silted up and the buccaneering adventures became more difficult. Brought up to date in the late 1990s, the Mere was been redesigned as a more natural setting for picnics, fishing and walking. *Treasure Island* remains but no longer with its pirates, and in 2012, a new snack bar opened on the shore of the Mere, now part of the Oliver's Mount Country Park. The pirates have moved to the sea proper and during the summer season, the *Hispaniola* sets sail from Scarborough Harbour.

Boulder Clay & Limestone

The geology around Filey and Scarborough is a key to the landscape and to human settlement, providing opportunities but also potential disasters. The high limestone cliffs provide an ideal and dramatic setting for the castle and a sheltered harbour for the port and for fishing. However, the crumbling, slipping and sliding cliffs soft clays and shales of the cliffs are hazardous and in 1993, the Holbeck Hall Hotel in Scarborough was destroyed in a landslide. The whole building slowly slipped down the cliff edge towards the sea. Indeed, this part of the coast is particularly unstable with problems due to inter-bedding of sandstones, shales and slippery mudstones, and of course the glacial boulder clay. Forty miles of this coastline is made of soft and shifting clay, resulting in erosion rates varying between 25 cm and 1½ m each year around Filey. Where the hard rock outcrops, the land protrude resolutely into the sea to from dramatic promontories and headlands, such as Filey Brigg, a landmark at the heart of Filey's identity.

Gordon Home on Filey Brigg in 1904:

> The Brig has plainly been formed by the erosion of Carr Naze, the headland of dark, reddish-brown boulder clay, leaving its hard bed of sandstone (of the Middle Calcareous Grit formation) exposed to the particular and ceaseless attention of the waves. It is one of the joys of Filey to go along the northward curve of the bay at low tide, and then walk along the uneven tabular masses of rock with hungry waves heaving and foaming within a few yards on either hand. No wonder that there has been sufficient sense among those who spend their lives in promoting schemes for ugly piers and senseless promenades, to realize that Nature has supplied Filey with a more permanent and infinitely more attractive pier than their fatuous ingenuity could produce. There is a spice of danger associated with the Brig, adding much to its interest; for no one should venture along the spit of rocks unless the tide is in a proper state to allow him a safe return. A melancholy warning of the dangers of the Brig is fixed to the rocky wall of the headland, describing how an unfortunate visitor was swept into the sea by the sudden arrival of an abnormally large wave, but this need not frighten away from the fascinating ridge of rock those who use ordinary care in watching the sea. At high tide the waves come over the seaweedy rocks at the foot of the headland, making it necessary to climb to the grassy top in order to get back to Filey.

Wading Birds & Sea Life

The wildlife here is justifiably famous since Filey Brigg in particular is well known as a 'sea watching' location. Shorebirds gather to forage and roost along the foot of the Brigg and in the abundant rock pools at low tide. Interesting waders such as purple sandpipers can be seen on the lower rock ledges in winter, and are present with the ubiquitous turnstones, dunlins, knot, and ringed plovers. On the landward side, the area is good for wildflowers and for commoner birds of open courtside. However, the Brigg is a notable site for watching the long-distance movement of birds at sea, and the height of the vantage point and the fact that it sticks abruptly out seawards make it excellent for this. Huge numbers of birds like gannets, kittiwakes, eider

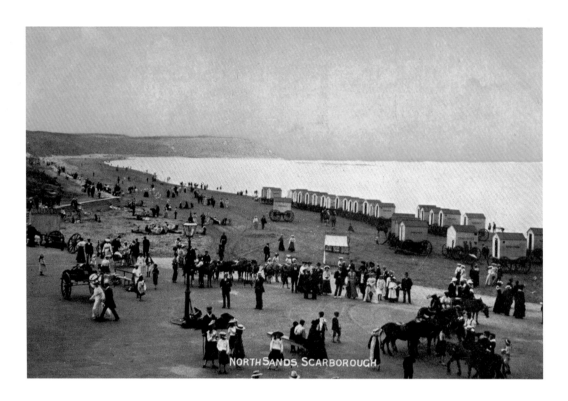

Above: North Sands with bathing huts, Scarborough, early 1900s.

Right: The Lighthouse, Scarborough, 1902.

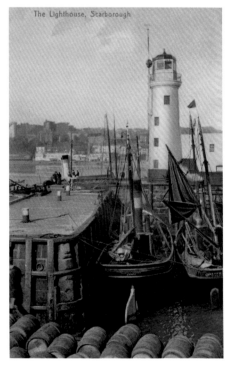

Ducks, other sea ducks, divers, grebes and much more can be watched. Also exciting, as it may turn up rarities, is that birds migrating along the coast may 'hop' over the landward end of the Brigg, and depending on weather conditions may drop down. All sorts of unusual wading birds and other species passing through are to be seen on some shallow pools nearby.

There is an active Filey Bird Observatory & Group (FBOG), whose aims include the recording and studying Filey's birdlife, and protecting and enhancing local habitats for wildlife. They own and manage several nature reserves. Close by is the Yorkshire Wildlife Trust's Filey Dams Nature Reserve, described as, 'The last remaining freshwater marsh of any size in the area, Filey Dams is a magnet for migratory birds but is also a haven for plants, small mammals and amphibians. This quiet gem consists of large freshwater lagoons surrounded by marsh and grassland grazed with cattle.' File Brigg Country Park is located just southwest of the Brigg.

The coastline around Scarborough is also excellent for sea watching and the sandy beaches attract wading birds in winter and on passage migration. The delicate, whitish, tiny sanderlings, looking almost like little clockwork mice, run up and down following the waves' edge at the interface between beach and tide. Their distinctive black legs stand out against the white plumage, as these restless little birds seem never to rest. Around the castle, expect to see kestrel and peregrine, and of course the noisy, squabbling, sociable jackdaws. On the lower crags and the rocks below, watch for rock pipits, a larger, greyer version of the common meadow pipit.

In summer, walk between Scarborough and Filey, or south from Filey towards Bempton, and you will see good numbers of sand martins nesting in the soft boulder clay cliffs.

Farmers, Fisherman, Healing Waters & the Seaside

Nicholas Pevsner wrote of Filey parish church, 'This is easily the finest church in the NE corner of the East Riding', and The Crescent is a feature of considerable charm and note. Although the settlement here and around the Brigg undoubtedly dates back to Roman times, and there would have been prehistoric people here before that, for most of its history, Filey was a tiny village of fishermen-farmers.

Scarborough, on the other hand, has had a relatively long and distinguished history, following its foundation as *Skarðaborg* sometime around AD 966, supposedly by Viking raider Thorgils Skarthi. However, there is no archaeological or documentary evidence to support such a claim, beyond a fragment of an Icelandic Saga. There would undoubtedly have been earlier usage and settlement of the area, especially the headland, and in the fourth century, a Roman signal station was located here. Evidence points to much earlier human occupation with Stone Age and Bronze Age settlements. Of the earlier Viking settlement, little remained at Domesday (1085) because, in the build up to the Battle of Stamford Bridge in 1066, it had been razed by rival Vikings under Tostig Godwinson and Harald Hardrada of Norway. This destruction and massacre of the population meant there was little to record in the Domesday survey for newly crowned King William I. A further complication was that the original settlement called Falsgrave, inland from the harbour, was a Saxon village not a Viking one. After this unpromising beginning, Scarborough recovered under the reign of King Henry II, and it was for him that the substantial stone castle was built on the headland. He also granted town charters in 1155 and 1163, to allow a market to be held on the sands, and establish rule of the town by burgesses.

In an unfortunate turn of events, King Edward II granted Scarborough Castle to his favoured friend, and rumoured homosexual partner, Piers Gaveston. One consequence of this unpopular move was that forces under the major Barons of Percy, Warenne, Clifford, and Pembroke besieged the castle. The beleaguered Gaveston was captured and subsequently transported first to Oxford, and then to Warwick Castle, where he was executed.

Despite these setbacks, Scarborough was growing in significance and influence. By the Middle Ages, under a royal charter of 1253, Scarborough Fair was permitted as a six-week trading festival, attracting merchants from all over Europe. This now famous event ran from Assumption Day (15 August), until Michaelmas Day (29 September). The fair was held for 500 years, from the thirteenth to the eighteenth century, and was commemorated in the traditional song 'Scarborough Fair':

> Are you going to Scarborough Fair?
> parsley, sage, rosemary and thyme...

The song was made globally famous by the Simon and Garfunkel song of the same name on their 1966 album *Parsley, Sage, Rosemary and Thyme*, and was released as a single after being featured on the soundtrack to the film *The Graduate* in 1968. This made it possibly the most widely heard folk song of all time.

During the English Civil War of the 1600s, Scarborough and its castle changed hands between Royalists and Parliamentarians seven times. This period for Scarborough included two lengthy and violent sieges, which left much of the town and its castle in ruins, and its economic success in some doubt. However, a new change in fortunes was about to begin.

During the seventeenth century, there was increasing interest in the healing properties, firstly of 'taking the waters', and later of bathing in them. However, at this early date physicians considered actually bathing or washing to be extremely dangerous and something to be undertaken only under strict medical supervision. Cleansing the skin with water unblocked the body's pores and thus allowed miasmas or diseases to enter. However, attitudes were changing and there was renewed interest in curative mineral-rich waters. It was in this context that, in 1626, Elizabeth Farrow discovered a stream of acidic water running from one of the cliffs to the south of the town. Such acid, iron-rich springs were exactly what the medical practitioners were searching for, and rapidly led to the birth to Scarborough Spa. As in many other cases of the discovery of miraculous healing springs, an eminent medical man wrote a bestselling book that described in detail the curative properties and the chemical analysis of the waters, and put the resort 'on the map'. In the case of Scarborough, it was Dr Robert Wittie was the man to create a national reputation for the waters. Wittie's *Scarborough Spaw or A Description of the Nature and Vertues of the Spaw at Scarbrough in Yorkshire* was published in the summer of 1660, firstly at York and then, to target the national audience, in London. It was this discovery and the subsequent publicity that triggered Scarborough's success as a tourism destination continuing to the present day. Dr Wittie's book about the remarkable spa waters attracted a flood of visitors to the town and as a result, Scarborough Spa became Britain's first seaside resort. Other developments, such as the famous rolling bathing machines, appeared on the sands in 1735. With its now famous waters and bracing climate, visitors from the upper classes and then the middle and educated classes flocked to the town. Georgian and then Victorian England boomed as urban centres and industry thrived. The growing, densely populated towns and cities spawned an increasingly affluent and leisured middle class. However, they also created a cesspit for disease, and this too was responsible for the demand for the healing spa resorts.

Health care at the time was minimal and a modern understanding of disease was still some way off. Therefore, with appalling water quality and sanitation, often poor diets and bad air pollution, and of course no antibiotics, diseases were rife. During the Middle Ages, people had suffered terribly and often died from horrible diseases such as bubonic plague (the Black Death), leprosy and syphilis. However, with urban, industrial boomtowns, the diseases were TB or consumption, cholera, typhus, and typhoid. In the countryside particularly, people still succumbed to the ague or marsh malaria. The consumptive artist or

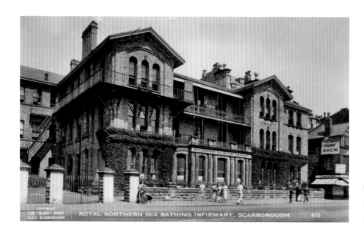

The Royal Northern
Sea-Bathing Infirmary,
Scarborough, probably 1950s.

writer seeking relief at a health resort such as Scarborough became an image for an age, and those seeking a cure (or at least an easing of the pain) headed to the health spas.

Anne Brontë was a famous example of a sad death due to consumption, and was the only member of the Brontë family not to be buried at Haworth. With Anne suffering from the early stages of consumption, it was felt that the change of air might help relieve the symptoms. Charlotte requested her friend Ellen Nussey accompany them on a journey to the seaside that began on 24 May 1849. The sisters and their friend booked rooms at Wood's Lodgings, No. 2, The Cliff, at Scarborough. However, the disease took a turn for the worse; Anne died and was buried at St Mary's church in Scarborough. Today this is the site of the Grand Hotel, and a blue plaque marks the location, stating that 'Anne Brontë 1820–1849 writer died in a house on this site on May 28th 1849', and there is a memorial slab on her grave in the churchyard.

In 1840, in her poem 'The Bluebell', Anne Brontë wrote of visiting Oliver's Mount.

> That day along a sunny road
> All carelessly I strayed,
> Between two banks where smiling flowers
> Their varied hues displayed.
> Before me rose a lofty hill,
> Behind me lay the sea...

With the mid-Victorian spread of the railway network, there was soon a cheap and easy way to get mass transport for people holidaying by the seaside. In 1845, the Scarborough to York railway increased the veritable tide of visitors. Maybe to cope with numbers, Scarborough railway station had the longest seat in any railway station in the world. Tourism and transport are intimately related. In 1841, there was talk of a possible railway link between York and Scarborough, and this likely influx of visitors persuaded a young architect called John Gibson to open Scarborough's first purpose-built hotel. Gibson designed and laid the foundations of a 'hotel', then a new term (from the words 'hostel' or 'hospital'), for a facility offering better class accommodation that an old-fashioned inn. The area chosen for this hotel was land above the popular spa building. The construction of the hotel passed from Gibson to a newly formed business of entrepreneurs, the South Cliff Building Company. The result was that on Tuesday 10 June 1845, Scarborough's first hotel opened and proved to be a marketing coup. The Grand Hotel, which would soon be the largest such establishment in

Europe, was not yet completed. Now, on the cliff above the new Spa Saloon (1839) was the majestic Crown Terrace with its centrepiece, the Crown Hotel.

John Fairgray Sharpin (1821–95) was the first owner-manager Crown Hotel, and set about making it one of the best hotels in the north of England and helping to ensure the ongoing development of South Cliff. Furthermore, Sharpin revived attractions such as the former Assembly Rooms and brought in the luxury of modern services such as 'hot, cold and shower baths', and even games such as billiards. Having first visited Scarborough in 1845, and confessed to being charmed at first sight, in 1853, at the young age of only thirty-one, he was elected Mayor of Scarborough. South Cliff's Prince of Wales Crescent, Belmont Terrace, Albion Road and Alfred Street were already under construction. When the Grand Hotel was completed in 1867, it was one of the largest hotels in the world and one of the first purpose-built mega hotels in Europe. Four towers represent the seasons, twelve floors represented the months, fifty-two chimneys the weeks, and originally 365 bedrooms the days of the year.

Fishy Tales from Scarborough

I recall some years back reading an article about tuna fishing at Scarborough, something that today seems so far-fetched, tuna being a threatened species and rarely seen off the British coast. However, back in the 1920s, with North Sea fish stocks still buoyant, tuna were indeed present. In 1929, the steam drifter *Ascendent* caught a 560-pound (250 kg) Atlantic bluefin tuna, and a Scarborough showman paid 50s to exhibit it as a tourist attraction. Subsequently, big-game tuna fishing from Scarborough began in 1930 when, using rod and line, Lorenzo 'Lawrie' Mitchell-Henry, when 50 miles offshore, landed a tuna weighing 560 pounds (250 kg). Catches varied from year to year and after a poor season in 1931, in the following season year Harold Hardy of Cloughton Hall, on board the trawler Dick Whittington, battled with a 16-foot tunny for over 7 hours before his line snapped. Four other passengers described the battle as 'the greatest fight they had ever seen in their lives', and Mrs Sparrow caught a 469-pound (212.7- kg) fish.

In 1933, the British Tunny Club (a gentlemen's club) was founded with its headquarters in Scarborough at a location that is now a restaurant with the same name. Indeed, big-game tuna fishing off Scarborough, mostly in the 1930s, was a sport practised by wealthy aristocrats and military officers. The Atlantic bluefin tuna (*Thunnus thynnus*) – at the time in Britain known as 'tunny' fish – is a large and powerful fish, perhaps the strongest fish in the world. Because of this, it is often the target of big-game fishermen. Surprisingly, today, the sea off the Yorkshire coast has produced a variety of records, including a world record for the size of tunny caught with rod and line. The fact was that, prior to the industrial fishing that developed during the twentieth century, tuna were present in the North Sea until the 1950s. The tuna population collapsed as commercial herring and mackerel fishing reduced its food supply and it became extinct in the region.

During the heyday of the Scarborough tuna, the town was a resort for high society. For many years, there was a women's world tuna challenge cup competition, and other records were broken. Col. (Sir) Edward Peel landed a world-record tunny of 798 pounds (362 kg), which exceeded the previous world record, caught off Nova Scotia by American champion Zane Grey, by 40 pounds (18.1 kg) . The British record, which still stands, was a fish weighing 851 pounds (386 kg) hooked off Scarborough in 1933 by Laurie Mitchell-Henry. In 1949, Lincolnshire farmer Jack Hedley Lewis took a larger fish (weighing 852 pounds or 386.5 kg) on a 160-pound line. However, as always with such matters, these things were extremely competitive and, reluctant to lose the record, Mitchell-Henry objected that the tunny had been hung for weighing on a wet rope and this affected the weight. The Tunny Club sustained the objection and the new record was expunged.

Local celebrity Henry Stapleton-Cotton was a pioneer of British tuna sport fishing, though two big fish he hooked in 1929 escaped. However, in each season up until 1939, fish of over 700

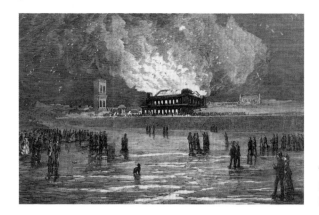

The burning of the Spa Saloon, Scarborough, which gutted the Grand Hall on 8 September 1876.

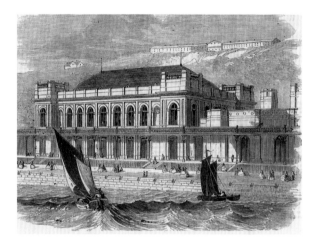

Victorian Music Saloon at Scarborough.

pounds (320 kg) were caught, and the amazing size of the specimens attracted large numbers of spectators. Attracted by tales of the huge fish, high society was drawn to Scarborough as a resort for the wealthy where sport was to be had only a few miles offshore.

Today it is hard to imagine the excitement and the sheer fashionability of Scarborough in the 1930s, with special trains from London to bring the socialites and stars to this seaside resort. Magazines published many sensational stories covering the personalities and the yachts that sailed to Scarborough. Visitors included a diverse range of the wealthy and the famous. There was Lady Broughton, the African big-game hunter who slept in a tent on the deck of her yacht; Col Sir Edward Peel, a hugely wealthy aristocrat boasting a large Sudanese-crewed steam yacht, *St George*. Lord Astor, the newspaper proprietor, attended along with actor Charles Laughton, Lord Crathorne (later chairman of the Conservative Party) and Lord Moyne of the Guinness family; the latter was assassinated in Egypt some years afterwards. Other visitors included celebrity yachtsmen like Tommy Sopwith, who challenged for the America's Cup in 1934 and 1937, and Baron Henri de Rothschild, who sailed in his 1,000-ton yacht *Eros*. In the case of the latter, he apparently fished for dab as his guests battled with tuna.

A remarkable incident was Lord Egerton catching fish weighing 691 pounds (313 kg) and 647 pounds (293 kg) on a single line. On another occasion, Col Henn, the Chief Constable of Gloucestershire, was towed a distance of 4 miles in his coble by a 707-pound (321-kg)

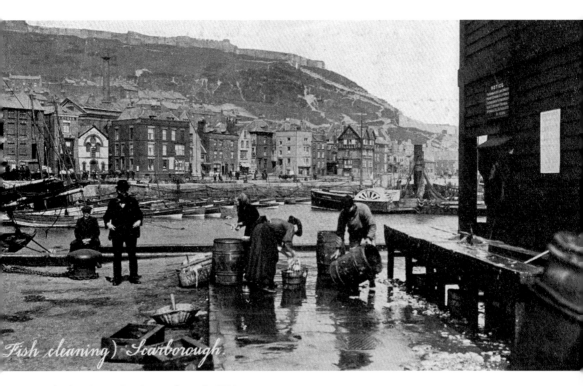

Fish cleaning at Scarborough, early 1900s.

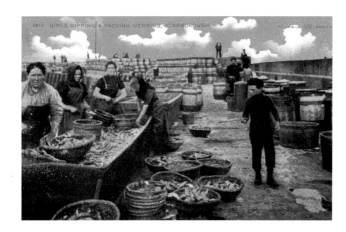

Girls gipping and packing herring, Scarborough, early 1900s.

tunny and Col Peel was obliged to search for him in his own yacht, *St George*. At this time, the widow of Sir David Yule, Lady Yule, was reputed to be the richest heiress in the British Empire. At Scarborough, she and her daughter Gladys sailed her 1,574-ton yacht *Nahlin*, now owned by Sir James Dyson, at the time complete with twelve bathrooms and a gymnasium. Dr Bidi Evans still holds the British women's record for Tunny with a 714-pound (324-kg) fish caught in 1947 from her father's yacht.

This amazing episode in Scarborough's history was rudely interrupted by the outbreak of the Second World War. Technical developments in commercial North Sea fishing after the war dramatically reduced the herring and mackerel stocks and directly led to the loss of tunny, the last being caught in 1954. Since that time, until the year 2000, no big fish had been hooked anywhere off the coast of Great Britain. Then in 2000, off the north-west coast of Ireland, a seventy-six-year old pensioner, Alan Glanville, a fishing novice using a rod for the first time, pulled the largest tuna caught off Britain for nearly fifty years. He caught a 353-pound (160- kg) fish one day and a 529-pound (240-kg) fish the next day. To put this in context, nowadays bluefin tuna are so much in demand that Japanese buyers will pay £50,000 or more for a single fish.

In so many ways (far more than this book leaves room for), Scarborough is a very special and surprising place.

> when my foot was on the sands and my face towards the broad, bright bay, no language can describe the effect of the deep, clear azure of the sky and ocean ... there was just enough heat to enhance the value of the breeze, and just enough wind to keep the whole sea in motion, to make the waves come bounding to the shore, foaming and sparkling.

> My footsteps were the first to press the firm, unbroken sands; nothing before had trampled them since last night's flowing tide had obliterated the deepest marks of yesterday, and left it fair and even, except where the subsiding water had left behind it the traces of dimpled pools, and little running streams...

> ...I should soon have been deluged with spray. But the tide was coming in; the water was rising; the gulfs and lakes were filling; the straits were widening: it was time to seek some safer footing.

The extract is from *Agnes Grey* by Anne Brontë, describing Scarborough beach, South Bay, a place she last visited last visited on 26 May 1849, just two days before her death.

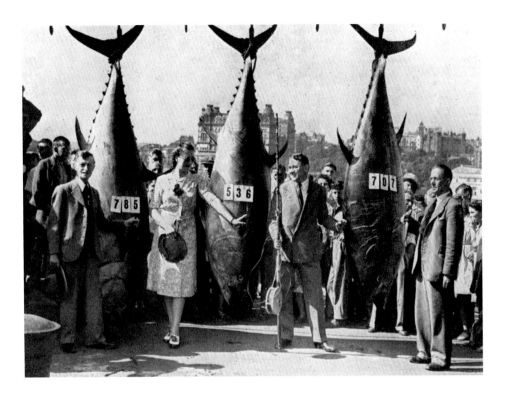

Above: Mr and Mrs Tom Laughton, brother and sister-in-law of actor Charles Laughton, with a morning's Tunny catch, 1930s.

Right: Scotch fisher girls, Scarborough, 1912.

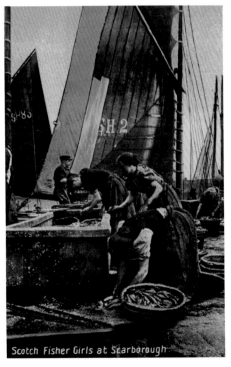

The Secret Cliffs and Wykes
of Robin Hood's Bay

Iconic and distinctive, Robin Hood's Bay and Fylingthorpe are among the most popular locations along this coastline. Along with these are lesser-known rather secret locations, such as Hayburn Wyke. The hidden bay itself and the dramatic cliffs and rock pools provide many opportunities for exploration, for wildlife watching and for walking, from the fishing village of Robin Hood's Bay or one of the other smaller settlements. What is more, all this area oozes nostalgia and the unique and ancient fishing heritage of these remote settlements. Robin Hood's Bay has a long and interesting history, from its spectacular geology to its former role at the heart of the local fishing industry.

The seashore and cliffs along the North Yorkshire coastline have excellent coastal footpaths and the visitors can see rare and interesting flora, along with seabirds and mammals. Grey seals and harbour porpoises can be viewed from the beaches or the high clifftops, and cliff-nesting seabirds provide noisy companions to any walk.

Robin Hood's Bay

Robin Hood's Bay is a small fishing village and a bay located within the North York Moors National Park, 5 miles south of Whitby and 15 miles north of Scarborough on the coast of North Yorkshire, England. Bay Town, its local name, is in the ancient chapelry of Fylingdales in the wapentake of Whitby Strand. The origin of the name is uncertain, and it is doubtful if Robin Hood was ever there, or even in the vicinity. However, folklore is no great respecter of history and an English ballad and legend tells the story of how Robin Hood encountered French pirates who had come to pillage the North East Coast and the boats of local fishermen. The story goes that the pirates surrendered and Robin Hood, in time-honoured fashion, returned the loot to the poor people in the village, which became known as Robin Hood's Bay.

Like many smaller settlements along the coast, the town was once served by the railway, with the Robin Hood's Bay railway station on the Scarborough to Whitby Railway line. The station opened in 1885 and, like so many others, closed in 1965. Today the disused track of the old railway is now a recreational footpath and cycleway, and the nearest railway station is in Whitby. Transport now is via the A171 main road north to Whitby and south to Scarborough. Bus services between Scarborough and Middlesbrough also pass through Robin Hood's Bay. For walkers, Robin Hood's Bay is the eastern end of Wainwright's Coast to Coast Walk, and is on the coastal section of the Cleveland Way long-distance footpath.

Hayburn Wyke

Hayburn Wyke is a secluded cove between Scarborough and Whitby. With the beach and woodland to discover, this hidden gem is the perfect setting for a picnic or a day of exploration. The rather unusual name, 'Hayburn Wyke', provides clues to the area's history. 'Hayburn' is an Anglo Saxon word meaning 'an enclosure (perhaps for hunting) by a stream', and 'Wyke' is the Old Norse word for 'sea inlet or creek', and occurs quite commonly along the North East coastline. These words combine to describe the landscape of Hayburn Wyke as can be seen today.

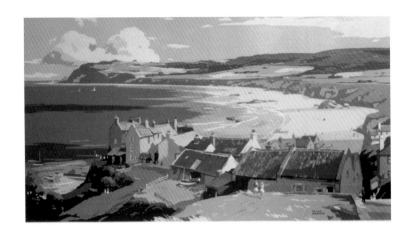

British Railways poster of Robin Hood's Bay, 1950s.

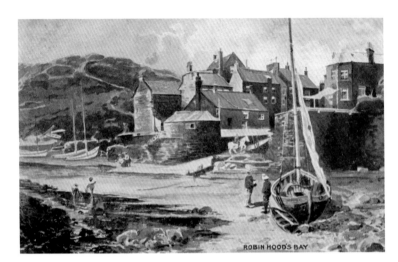

Robin Hood's Bay, 1920s.

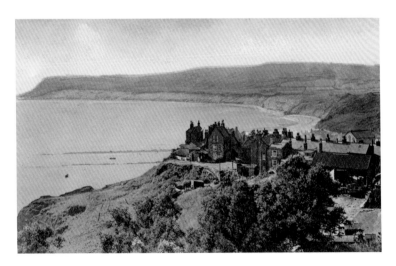

Robin Hood's Bay, 1936.

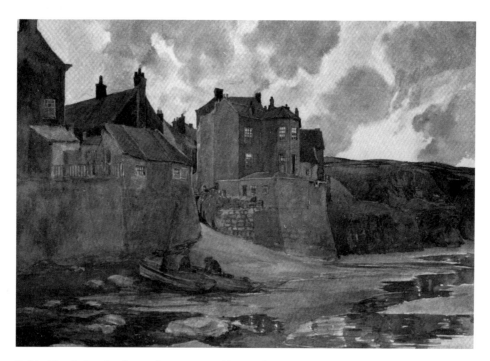

Robin Hood's Bay by the seafront, pictured by Gordon Home, 1904, *Yorkshire Coast and Moorland Scenes.*

The most notable feature is the picturesque Hayburn Wyke waterfall, which is so close to the sea that its water falls directly onto the rocky beach below. A walk from here through the wooded valley leads to a private inlet. The dramatic, almost sheer cliffs, covered with dense woodland vegetation provide the backdrop to this secret and very special place. The Hayburn Wyke Inn, which a few years back underwent renovation, offers chance of high-quality food and drink before or at the end of your visit.

High Cliffs, Fossil Beds & Alum Works

Robin Hood's Bay is justifiably famous for the large number of fossils found in the soft shale rocks on the beach, which, together with abundant marine life, provide a great attraction. In 1912, Professor Walter Garstang of Leeds University and Professor Albert Denny of the University of Sheffield established the Robin Hood's Bay Marine Laboratory, and this facility continued here until the 1980s.

Artist and writer Gordon Home (1904) describes the impression of arriving at Robin Hood's Bay.

After rounding the North Cheek, the whole of Robin Hood's Bay is suddenly laid before you. I well remember my first view of the wide sweep of sea, which lay like a blue carpet edged with white, and the high escarpments of rock that were in deep purple shade, except where the afternoon sun turned them into the brightest greens and umbers. Three miles away, but seemingly very much closer, was the bold headland of the Peak, and more inland was Stoupe Brow, with Robin Hood's Butts on the hill-top. The fable connected with the outlaw is scarcely worth repeating, but on the site of these butts urns have been

dug up, and are now to be found in Scarborough Museum. The Bay Town is hidden away in a most astonishing fashion, for, until you have almost reached the two bastions which guard the way up from the beach, there is nothing to be seen of the charming old place. If you approach by the road past the railway station it is the same, for only garishly new hotels and villas are to be seen on the high ground, and not a vestige of the fishing-town can be discovered. But the road to the bay at last begins to drop down very steeply, and the first old roofs appear. The oath at the side of the road develops into a very lone series of steps, and in a few minutes the narrow street flanked by very tall houses, has swallowed you up.

Robin Hood's Bay was built in a fissure between two sheer cliffs, essentially a steep valley with a fast-flowing stream the King's Beck. Most of the village houses were constructed of sandstone with red-tiled roofs. The main street is New Road, which descends steeply from the cliff top where the Manor House, some newer houses and St Stephen's church stand. The road passes through the village, crosses the beck, and reaches the beach via a cobbled slipway known as Wayfoot, where the beck discharges onto the beach. The cliffs are composed of Upper Lias shale capped by Dogger and false-bedded sandstones and shales of the Lower Oolite.

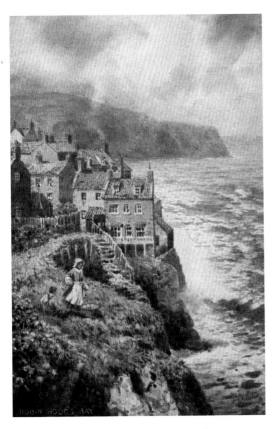 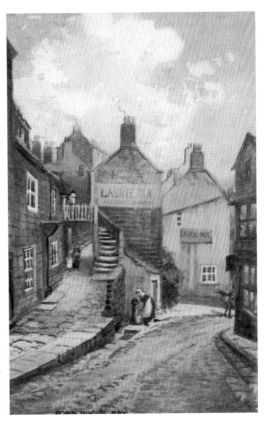

Above left: Robin Hood's Bay, early 1900s.

Above right: Robin Hood's Bay, early 1900s.

Everything is very clean and orderly, and, although most of the houses are very old, they
are generally in a good state of repair, exhibiting in every case the seaman's love of fresh
paint. Thus, the dark and worn stone walls have bright eyes in their newly-painted doors
and windows. Over their door-steps the fishermen's wives are quite fastidious, and you
seldom see a mark on the ochre-coloured hearth-stone with which the women love to
brighten the worn stones. Even the scrapers are sleek with blacklead, and it is not easy to
find a window without spotless curtains. At high tide, the sea comes half-way up the steep
opening between the coastguards' quarters and the inn, which is built on another bastion,
and in rough weather the waves break hungrily on to the strong stone walls, for the bay is
entirely open to the full force of gales from the east or north-east.

Gordon Home (1904)

Seashore & Marine Life

Robin Hood's Bay is justifiably famous for its marine wildlife and especially for the
educational and pleasure use of the area. For maybe 100 years or more, school and university
students have visited here to study the marine ecology. The extensive rock pools uncovered
at low tide make the site ideal for this activity. Ever since Victorian times, holidaymakers
have flocked to the seaside to explore the pools and to study their hidden wildlife secrets.
Nearby cliffs are home to gulls, including kittiwakes, and to fulmars, a member of the petrel
family. Cormorants, gannets and sea ducks are seen in the bay. Along the lower cliffs, mostly
shrouded in thickets of blackthorn and bramble, the breeding birds include warblers and
other summer visitors, and spring or autumn bring good numbers of migrant birds. The
shoreline and rock pools attract wading birds such as oystercatchers and turnstones.

The woodland clothing the cliffs around Hayburn Wyke offers peaceful walks and the chance
to watch wildlife, with roe deer, badgers and foxes all commonly found in the area. Keep your
eyes and ears open for breeding birds such as common redstart, blackcap, willow warbler, great
spotted woodpecker, green woodpecker and pied flycatcher. Dense blackthorn scrub offers
wonderful habitat for wintering birds and especially those migrating in spring and autumn.

Vikings, Smugglers & Sailors

In Fylingdales, by around AD 1000, Vikings from Norway and Denmark settled the
neighbouring hamlet of Raw and the village of Thorpe or Fylingthorpe. However, following
northern uprisings in 1069 after the Norman Conquest in 1066, much of the area, in the
terms of the Domesday account of 1085, was laid waste. The Normans then proceeded to
divvy up the lands they had won. William the Conqueror gave Fylingdales to Tancred the
Fleming and he later sold it to the Abbot of Whitby. The earliest settlements here were
around a mile inland at Raw, but by around AD 1500 , there was a settlement on the coast
where Robin Hood's Bay is now located. John Leland, the antiquary to King Henry VIII,
noted 'Robin Hoode Baye' in his account of 1536, describing it as 'A fischer tounlet of 20
bootes with Dok or Bosom of a mile yn length.' Surprising today, sixteenth-century Robin
Hood's Bay was more important a port than Whitby. Rotterdam Maritime Museum even
has a tiny picture of the village of tall houses and an anchor on old charts of the North
Sea, published in 1586 by Waghenaer. After the progressive Dissolution of the Monasteries
following 1540, Whitby Abbey and its lands were made the property of King Henry VIII.
Place names such as King Street and King's Beck date from this time and undoubtedly made
a point about the changed ownership.

For many generations of bay folk, the main occupations were fishing and farming. The
former reached its peak in the mid-nineteenth century fishermen. They used the traditional
coble, a distinctive type of open fishing developed on the North East Coast of England and

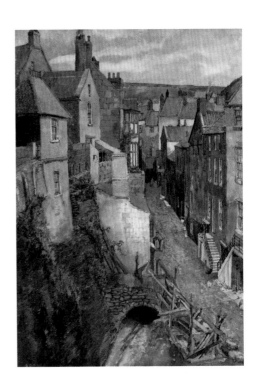

Robin Hood's Bay, from Gordon Home, 1904,
Yorkshire Coast and Moorland Scenes.

probably descended from Viking longboats, for line fishing in winter. A larger boat was employed for herring fishing at other times. Fish were loaded into panniers on ponies or donkeys, and men and women walked or rode up the steep hills, inland and over the open moorland tracks. The destination was either Pickering or York. With a booming trade in fish, there were opportunities for whole families to be employed in fishing. Between 1650 and 1750, because of the boom in the local economy, many new houses were built in the village. Individual families often owned or part owned their own cobles, and in later years, some even owned oceangoing boats. So for much of its history, the main legitimate activity of the people of Robin Hood's Bay was fishing, but this started to decline in the late nineteenth century and was gradually supplemented, then almost replaced by tourism.

The village grew into a small town, with a maze of tiny streets, and its reputation as a haunt of smugglers grew as well. There is even a supposed network of underground passageways linking the houses to facilitate easy and discrete movement of people and contraband. During the late eighteenth century, with continental Europe just across the sea, smuggling was rife on the Yorkshire coast. Ships from the continent brought goods to be taken and distributed by contacts on the land. The men behind the operations were members of financial syndicates who made profits without the direct risks taken by the seamen and the villagers. A diversity of goods was brought ashore to avoid duty, with tea, gin, rum, brandy and tobacco among the contraband goods smuggled into Yorkshire. Much of the illegal importation came from France and the Netherlands.

Both the risks and rewards were great, and the conflicts between smugglers and the excise men, both on land and at sea, are the stuff of adventure stories. For example, in 1773, two excise cutters, the *Mermaid* and the *Eagle*, were outgunned and chased out of the Bay by three smuggling vessels, a schooner and two shallops, the latter being light sailing boats used mainly for coastal fishing or as a tender for bigger ships, and sometimes armed with

canon. Then, in 1779, there was a pitched battle between smugglers and excise men in Robin Hood's Bay dock. The reason for the conflict was a stash of over 200 casks of brandy and geneva or gin and fifteen large bags of tea, then a valuable commodity.

Like other North Yorkshire towns, Robin Hood's Bay has literary connections, with the author Leo Walmsley one of its more famous sons. He was actually born in Shipley in West Yorkshire in 1892, but within two years, his family moved to Robin Hood's Bay. Here he was schooled at the old Wesleyan Chapel. In 1912, for the princely sum of 5s a week, young Leo was appointed as curator and caretaker of the Robin Hood's Bay Marine Laboratory. The town was the setting for the series of Bramblewick novels (*Three Fevers, Phantom Lobster, Foreigners* and *Sally Lunn*). After serving with distinction in the First World War, Walmsley took a writing career and moved to Cornwall where he was friends with Daphne du Maurier. Contemporary children's poet Michael Rosen was the fifth children's laureate, holding the position from June 2007 until 2009, and wrote *Robin Hood's Bay*.

All along the East Coast, with busy shipping lanes as well as more local fishing activities, the sea can be a fickle acquaintance, and shipwrecks in times past were a regular occurrence. One example, is that of a brig called *Visitor,* which, during a violent storm, ran aground in Robin Hood's Bay on 18 January 1881. Bearing in mind the limited resources of the region and the difficulties inherent in road transport in this cliff-dominated area, the response was heroic. To have any chance of saving the ship's crew, the Whitby lifeboat was pulled 6 miles overland by eighteen horses, and 200 men cleared the 7-foot snowdrifts along the route. However, the road down to the sea through the middle Robin Hood's Bay Village was narrow with difficult bends. To solve the problem, the men had to go ahead of the boat to demolishing garden walls, uprooting bushes, removing other obstructions and making way through for the lifeboat carriage. A mere two hours after leaving Whitby, the lifeboat was launched, and the crew of the *Visitor* were rescued at the second attempt.

Whitby, Sandsend, Runswick Bay & Staithes:
Wild North Yorkshire – Nature and Wildlife Along the Dinosaur Coast

Whitby and nearby Sandsend are the jewels in the crown of tourism on the northern Dinosaur Coast, complementing but different from Scarborough to the south. Distinctive cuisine, such as kippers from the Whitby smokeries, is still a part of the ambience of the area. Whitby also boasts a strong cultural tradition and that grows and evolved even today. Based on the Dracula associations, the town is a centre for Goth culture, paraphernalia and events. The church and the ruined abbey draw visitors interested in culture, history, religion and a beautiful location. Further north are the smaller but equally picturesque fishing villages of Staithes and Runswick Bay.

WHITBY by E. Teschemacher

Behold the glorious summer sea
As night's dark wings unfold,
And o'er the waters, 'neath the stars,
The harbour lights behold.

Whitby

Whitby itself is a gem of a town, and today is a beacon holiday resort. Its history relates to origins as a seaside town, port and civil parish within the Borough of Scarborough. Located at the mouth of the River Esk, Whitby has established an enviable reputation for tourism relating to maritime, mineral, religious and literary heritage. Above the East Cliff are the ruins of Whitby Abbey, once home to Caedmon, the earliest recognised English poet. The site has been a place of religious significance from at least the so-called dark ages.

However, with a sheltered harbour and at the mouth of a significant river, the fishing port grew during the Middle Ages and established important herring and whaling fleets. Along with the nearby fishing village of Staithes, where Captain Cook learned seamanship, became a centre for maritime activities.

The major economic activity today is tourism and this has been important for Whitby since Georgian times, developing rapidly when the railway arrived in 1839. For modern-day Whitby, its attraction for tourists is enhanced by its location so close to the high moors of the National Park and being on Heritage Coastline. However, there is much more to Whitby and association with Bram Stoker's Victorian novel *Dracula,* and the spin-off films and other activities, has led to an iconic status for 'Goth' culture and festivals.

 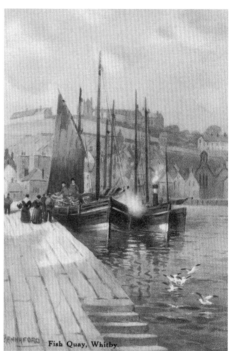

Above left: Caedmon Cross Whitby, early 1900s.

Above right: Whitby Fish Quay, early 1900s.

Sandsend

> Go where you will in Yorkshire, you will find no more fascinating woodland scenery than that of the gorges of Mulgrave. From the broken walls and towers of the old Norman castle the views over the ravines on either hand—for the castle stands on a lofty promontory in a sea of foliage—are entrancing; and after seeing the astoundingly brilliant colours with which autumn paints these trees, there is a tendency to find the ordinary woodland commonplace. The narrowest and deepest gorge is hundreds of feet deep in the shale. East Row Beck drops into this canon in the form of a water-fall at the upper end, and then almost disappears among the enormous rocks strewn along its circumscribed course. The humid, hot-house atmosphere down here encourages the growth of many of the rarer mosses, which entirely cover all but the newly-fallen rocks.

Gordon Home (1904)

Sandsend is a small fishing village, near to Whitby in the Scarborough District and part of the civil parish of Lythe. The Mulgrave Estate still owns much of the western part of the village and The Valley, and today it is one of the most desirable property locations on the Yorkshire coast. Formerly two settlements, Sandsend and the neighbouring village of East Row, it is an extended village situated at the foot of Lythe Bank with picturesque

old cottages built against a backdrop of cliffs, and with two meandering streams leading to the sandy beach. The two villages united when extra cottages were built for workers in the nearby alum industry. Hard to imagine today, Sandsend was an important centre for the alum works and associated industries. However, with road access difficult, the railway was a godsend. From 1855 to 1958, Sandsend was served by the Whitby, Redcar and Middlesbrough Union Railway, with Sandsend railway station opening in 1883, but closing in 1958.

The setting is stunning and on entering Sandsend, it is hard not to be impressed by the magnificent sweep of the bay with the headland and cliffs to the north and the distant, evocative majestic ruins of Whitby Abbey to the south. This is a truly delightful village with pubs and cafés dotted along the sea front and on a stormy day, almost in the North Sea itself. There is a lovely 3-mile walk along the beach to Whitby and surfers often make the most of the waves. Northwards is a delightful clifftop walk along the disused former railway line.

Staithes

Staithes was once one of the largest fishing ports on the North-East Coast and an important source of the minerals jet, iron, alum and potash. Staithes is a very attractive tourist destination today. Roxby Beck, the stream running through Staithes, is the border between the Borough of Scarborough and Redcar and Cleveland. The village has a sheltered harbour,

Barnby Beck, Sandsend, 1970s.

Old cottages at Sandsend around 1911.

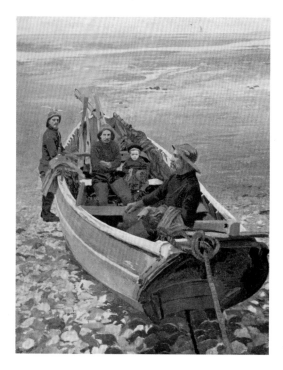

Staithes fishing family from Gordon Home,
1904, *Yorkshire Coast and Moorland Scenes.*

bounded by high cliffs and two long breakwaters, and a mile westwards is Boulby Cliff,
where alum was once mined. The ruins of the mines are still visible from on the cliff
top when walking towards Skinningrove on the Cleveland Way. Staithes is a Mecca for
geologists and some of the major fossil finds have been from this area.

Runswick Bay

With a sweeping, sheltered bay and charming red-roofed cottages, Runswick Bay has a
reputation as one of the Yorkshire Coast's prettiest holiday destinations. The sandy beach
that was once a safe anchorage for local fishing boats has developed into a place to play, to
walk and to watch wildlife. The cliffs are ideal for walks and the rock pools for searching
for anemones, crabs, other marine life, and of course form fossils.

The tiny village in the civil parish of Hinderwell, is tightly huddled on the northern end
of the bay with narrow lanes and the ancient thatched cottage of the local coastguard, a
single pub and a tiny café, which sells delicious homemade cakes. The scenic paths of the
Cleveland Way lead both north and south.

This sandy beach, lapped by the blue waves of Runswick Bay, is one of the finest and most
spectacular spots to be found on the rocky coast-line of Yorkshire. You look northwards across
the sunlit sea to the rocky heights hiding Port Mulgrave and Staithes, and on the further side
of the bay you see tiny Runswick's red roofs, one above the other, on the face of the cliff.
Here it is always cool and pleasant in the hottest weather, and from the broad shadows cast
by the precipices above one can revel in the sunny land- and sea-scapes without that fishy
odour so unavoidable in the villages. When the sun is beginning to climb down the sky in
the direction of Hinderwell, and everything is bathed in a glorious golden light, the ferryman
will row you across the bay to Runswick, but a scramble over the rocks on the beach will be

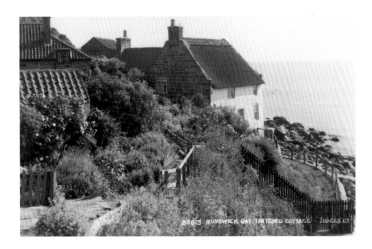

Runswick Bay, 1950s.

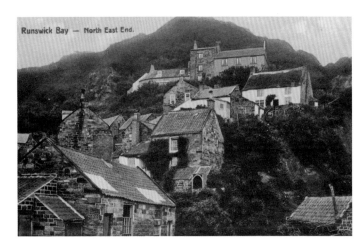

Runswick Bay north-east end, early 1900s.

repaid by a closer view of the now half-filled-up Hob Hole. The fisherfolk believed this cave to be the home of a kindly-disposed fairy or hob, who seems to have been one of the slow-dying inhabitants of the world of mythology implicitly believed in by the Saxons. And these beliefs died so hard in these lonely Yorkshire villages that until recent times a mother would carry her child suffering from whooping-cough along the beach to the mouth of the cave. There she would call in a loud voice, 'Hob-hole Hob! my bairn's getten t'kink cough. Tak't off, tak't off.

The same form of disaster that destroyed Kettleness village caused the complete ruin of Runswick in 1666, for one night, when some of the fisherfolk were holding a wake over a corpse, they had unmistakable warnings of an approaching landslip. The alarm was given, and the villagers, hurriedly leaving their cottages, saw the whole place slide downwards, and become a mass of ruins. No lives were lost, but, as only one house remained standing, the poor fishermen were only saved from destitution by the sums of money collected for their relief.

Scarcely two miles from Hinderwell is the fishing-hamlet of Staithes, wedged into the side of a deep and exceedingly picturesque beck.

Gordon Home (1904)

Dinosaur Shales & Spectacular Cliffs

For around 35 miles (56 km), stretching from Staithes in the north, to Flamborough in the Yorkshire East Riding, the coast is a designated part of the North Yorkshire and Cleveland Heritage Coast, and known as the 'Dinosaur Coast', the 'Fossil Coast' or the 'Jurassic Coast'. At Whitby, the rocks are rich in fossil evidence of past life with, for example, dinosaur footprints visible. The rock strata contain both fossils and organic remains, including the famous mineral, jet. Remarkable and important finds have been made here, including, in 1841, the petrified bones of an almost complete crocodile and a plesiosaur measuring 15 feet 6 inches (4.72 m) in length, and 8 feet 5 inches (2.57 m) wide. Smaller fossils abound in the soft shales including ammonites, or 'snake stones' in the alum shales. The Hildoceras ammonites are named in honour of St Hilda of Whitby. Both Whitby Museum and the Rotunda Museum in Scarborough have excellent collections of actual fossils or replicas of the famous finds from the area.

The local geology has had a major influence on the development and the economy of Whitby. In and around the town, jet and alum were mined locally. The Romans and later settlers exploited jet from this area, and it became immensely popular and fashionable in Victorian England. When Queen Victoria wore jet as part of her mourning clothes after the death of her beloved Prince Albert, it became a 'must have' fashion accessory for Victorians in mourning. At one time, the number of jet workers in Whitby outnumbered the fishermen.

Other hugely important minerals for Whitby were alum for dye fixing, which became a major trade for a number of centuries before being replaced by a synthetic substitute, and ironstone.

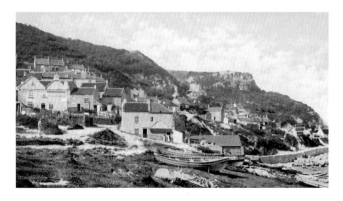

Runswick Village, early 1900s.

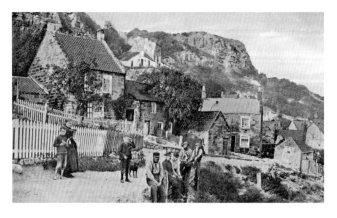

Runswick Village, early 1906.

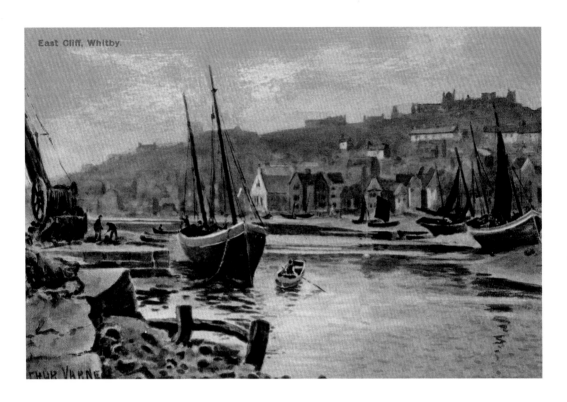

East Cliff, Whitby.

Above: East Cliff Whitby, early 1900s.

Right: Old houses and parish church, East Cliff, Whitby, early 1900s.

However, another influence of the geology in this area has been less favourable, and this is its inherent instability. In recent years, this has been especially notable on the headland of East Cliff and around St Mary's church. The cause of the problem is mostly to do with the layers of porous, hard sandstones interbedded with soft, impervious shales and mudstones. In wet weather, as we have experienced in recent years, the water seeps through the sandstone but cannot penetrate the shales or mudstones, so water builds up until it emerges at ground surface where the shales break out. The mudstones easily liquefy and the weight of the rocks above squeeze the whole mix a little like an old-fashioned ice-cream wafer sandwich under pressure. The result is a dramatic loss of stability and both hard sandstone and soft shale come crashing down as massive landslips. Gordon Home, writing in 1904, referred to this sort of process. The consequences can be dramatic, dangerous, and horrific.

> The walk along the rocky shore to Kettleness is dangerous unless the tide is carefully watched, and the road inland through Lythe village is not particularly interesting, so that one is tempted to use the railway, which cuts right through the intervening high ground by means of two tunnels. The first one is a mile long, and somewhere near the centre has a passage out to the cliffs, so that even if both ends of the tunnel collapsed there would be a way of escape. But this is small comfort when travelling from Kettleness, for the down gradient towards Sandsend is very steep, and in the darkness of the tunnel the train gets up a tremendous speed, bursting into the open just where a precipitous drop into the sea could be most easily accomplished.
>
> The station at Kettleness is on the top of the huge cliffs, and to reach the shore one must climb down a zigzag path. It is a broad and solid pathway until half-way down, where it assumes the character of a goat-track, being a mere treading down of the loose shale of which the enormous cliff is formed. The sliding down of the crumbling rock constantly carries away the path, but a little spade-work soon makes the track firm again. This portion of the cliff has something of a history, for one night in 1829 the inhabitants of many of the cottages originally forming the village of Kettleness were warned of impending danger by subterranean noises. Fearing a subsidence of the cliff, they betook themselves to a small schooner lying in the bay. This wise move had not long been accomplished, when a huge section of the ground occupied by the cottages slid down the great cliff and the next morning there was little to be seen but a sloping mound of lias shale at the foot of the precipice. The villagers recovered some of their property by digging, and some pieces of broken crockery from one of the cottages are still to be seen on the shore near the ferryman's hut, where the path joins the shore.
>
> Gordon Home (1904)

However, this is not the only geological threat to the landscape of this area. Immediately north of Whitby, the cliffs are made up of colossal amount of boulder clay dumped here after the last glaciation retreated. The soft clay reaches down to the beach where storm tides and surges easily erode it. Worse still, from the landward side, water cuts under the clays and causes instability and erosion so that whole sections collapse onto the beach. If nothing is done to prevent further erosion, Whitby Golf Course maybe reduced to a pitch and putt.

Coastal Wildlife & Clifftop Woods

Whitby provides a good starting point to watch local sea life, with grey seals, for example, occasionally coming into the harbour area. The massive stone walls of the piers can be habitat for uncommon wading birds like Purple Sandpipers in small winter flocks, and for the ubiquitous

turnstones. Perhaps the most typically evocative birds of Whitby are the ever-present seagulls, with cries of herring gulls and lesser black-backs ringing out across the old town. From the harbour, there is an easy coastal walk along the beach to Sandsend, with the possibilities of birds like Arctic skuas and common or sandwich terns, and harbour porpoises.

Beyond Sandsend, the Cleveland Trail follows the disused railway line northwards and through former alum works and quarries. It is hard to imagine how this might have looked two centuries ago, but something akin to Dante's Inferno would be a good impression. Along the track there are planted Sycamore woods and ancient oak woods too. In spring, the wildflowers hark back to a long history of woodland here. Bluebells and dog's mercury mixed with greater woodrush, wood sorrel, honeysuckle and more, are all indicators of ancient woods. In the old industrial areas, those a little inland are now vegetated with a remarkable mix of heath, grassland, woodland and wetland habitats. Willows and reed mace thrive where water gushes from the layers of impermeable shale rocks. To the seaward of these areas, where huge piles of alum were roasted, the clifftops remain naked and eroded with just the occasional patch of heather or grass in the more sheltered or damp spots. This remarkable lunar landscape has its own distinctive attraction and is a reminder of a long-forgotten industrial past. Along the Cleveland Trail, the banksides are clothed with heathland flowers, with rich flowery grasslands, and with fragments of flora from former woods and hedgerows. These landscapes are rich in birdlife like warblers and finches, and in butterflies and other insects too. Kestrel and peregrine enjoy the habitat of the high cliffs and the seabirds thrive here as well. On slopes sheltered from the sea winds and in areas unaffected by industrial exploitation, some of the crags have remarkable ancient trees, some multi-stemmed coppices, and these cling by their aged roots to the unstable rocks.

Evening at Whitby from Gordon Home, 1904.

Christianity, Whaling & Dracula

The earliest record of a permanent settlement at Whitby was in AD 656. As 'Streanœhealh', it was the place where Oswy, the Christian King of Northumbria, founded the first abbey. This was under the supervision of Abbess Hilda. Famously, with Whitby as a centre for Christian teachings and knowledge, the Synod of Whitby was held there in AD 664. However, by AD 867, Viking raiders had destroyed the monastery as the whole coastline suffered the aggression of longship raiding parties. Stability was eventually restored and, post-conquest, the abbey was refounded in AD 1078. Around this time, the town changed its name to Whitby, Old Norse for 'white settlement', and in subsequent centuries, Whitby grew as a modest fishing settlement. By the eighteenth century, it emerged as a significant port and a centre for both shipbuilding and whaling. The local trade in the mineral alum and the manufacture of Whitby jet jewellery boosted the port.

The abbey suffered under the Dissolution by Henry VIII, the building largely demolished and its stone used to construct a grand house nearby. However, today, the ruined abbey, juxtaposed with the ancient church of St Mary's, stands at the top of the East Cliff to form the town's oldest and most prominent landmark. Indeed, the skyline silhouette of the abbey ruins appealed strongly to the Romantics of the 1700s and 1800s. Nowadays, a swing bridge crossing the River Esk and the harbour joins the two halves of the ancient town, the East Cliff and the West Cliff. It has been a bridging point since at least medieval times and several bridges have spanned the river. The current bridge, built in 1908, has a 75-foot (23-m) span that separates the upper and lower harbours, which total around 80 acres (32 ha). The harbour is sheltered from the ferocity of North Sea gales by massive stone-built piers, Grade II listed structures the East Pier and West Pier. Around the harbour and extending upriver are huddled buildings associated with the fishing industry, plus abundant restaurants, cafés, pubs, gift shops and amusement arcades. Something not to be missed is the Dracula Experience! The Captain Cook Museum provides a more serious insight to the history of Whitby, and in a small park above the town is the excellent local museum. Simply walking through the town, you absorb aspects of its maritime heritage, with statues of Captain Cook and of William Scoresby, and the famous whalebone arch on West Cliff, commemorating the seafaring traditions. The strong literary traditions include numerous authors and books, television and cinema, perhaps most famously Bram Stoker's *Dracula*.

Born in 1789 in the village of Cropton near Pickering, 26 miles south of Whitby, William Scoresby Jnr was a pioneering Arctic explorer and a scientist of the highest repute. His father had made a fortune in Whitby's Arctic whale fishery and, among other things, invented the barrel crow's nest, a lookout for sailing ships. Aged only eleven years, William Jnr undertook his first voyage with his father, but then returned to school. Following around ten years of further seafaring and research, he returned and went to read divinity at Cambridge. He continued to research, write and lecture on scientific and social issues, and to undertake expeditions. Scoreby contributed significantly to knowledge of the Greenland coast and to the search for the Northwest Passage, and pioneered ideas of geo-magnetism. Shortly before his death in 1857, he travelled to Australia on the ironclad ship the *Royal Charter*, an ill-fated ship wrecked in a massive storm off Anglesey in 1859, with the loss of 459 lives.

Commercial whaling is something that we view today with horror and disgust, but to the eighteenth-century business entrepreneurs of Whitby, it was an opportunity to be seized. In 1753, the first Whitby-based whaling ship set sail to Greenland. Then, by 1795, Whitby was a major whaling port. Indeed, throughout the late 1700s, with men like Scoresby Snr making fortunes in whaling, Whitby grew in size and wealth. Using local oak timber, the town extended its commercial activities to include shipbuilding, in 1790/91 constructing 11,754 tons of shipping. This made it the third largest shipbuilder in England, after London and Newcastle. The levies of taxes on imports entering the Whitby were used to improve and

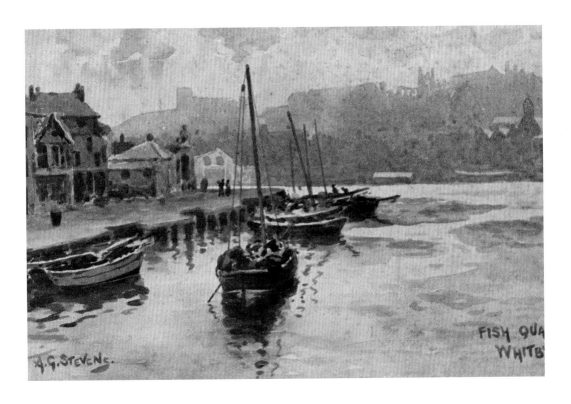

Above: Fish Quay, Whitby, early 1900s.

Right: The Church Steps, Whitby, 1953.

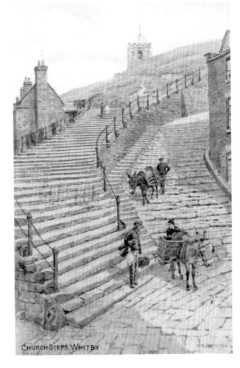

extend the town's twin piers, to improve the harbour and permit the growth of trade. The most successful whaling year was 1814, when eight ships caught 172 whales and the catch of whaling ship the *Resolution* alone producing 230 tons of oil. The economic importance of this oil is often forgotten, but in an age pre-petrochemicals, it was hugely significant. However, the whales were sources of a wide variety of other materials too. The carcasses of the 1814 catch, for example, produced 42 tons of whale bone used for 'stays' in the corsetry trade until changed fashion made them redundant.

The oil from the toothed whales (such as sperm whales) and the baleen whales (such as humpback, rights and blue whales) differed in chemical make-up and therefore in both its value and uses. Whale oil was used for heating, lubrication, soap, candle wax, and the processing of textiles and rope, but its main value was as a fuel source for lamps. Whale oil was greatly superior to ordinary animal tallow or beeswax, and importantly produced a smokeless flame. Globally, the peak year for sperm whale oil was 1846, though numbers were already falling and Whitby had ceased whaling. The sperm whales had been hunted mercilessly throughout the mid-1700s and early 1800s, an individual large animal yielding around 3 tons of sperm oil from cavities in the head, an incredibly valuable commodity and free for the taking. Across the developed world, Americans and Europeans started using sperm whale oil to fuel lighthouses, street lamps and public buildings. Wealthier people stopped using homemade tallow candles, and the spermaceti candle was so popular that a new light standard, used to this day, was defined as the lumen. From fashionable homes to urban streetlights, for about a century, this barbaric practice illuminated the Christian world. In the nineteenth century alone, approximately 236,000 whales were slaughtered.

Up to the late 1700s, town streets were mostly unlit at night, making them dangerous places to walk abroad. However, whale blubber could be boiled to produce oil to be burnt in either domestic lighting or for street illumination. A pioneering experiment in this was with whale oil used in lamps in four oil houses on the Whitby harbourside. Subsequently, whale oil was used for street lighting until the advent of coal gas made gas lighting of streets widespread. Finally, with reduced demand, the Whitby Whale Oil and Gas Company changed into the Whitby Coal and Gas Company. By the mid-1800s, the market for whale products was falling, as whale populations collapsed and catches became too small to be economic. By 1831, only one whaling ship, the *Phoenix*, remained, and Whitby's short-lived whaling boom was over but never forgotten.

As whaling rapidly declined, Whitby benefitted from the coastal trade in energy between the Newcastle coalfield and London. The town engaged in the commerce by both shipbuilding and supplying transport. Indeed, in his youth, the explorer James Cook famously learned his trade on colliers, shipping coal from the Whitby. Fittingly, HMS *Endeavour*, the ship Cook commanded on his voyage to Australia and New Zealand, was built in Whitby in 1764. Originally a coal carrier called the *Earl of Pembroke*, she was built by Whitby shipbuilder Tomas Fishburn and in 1768 acquired by the Royal Navy, refitted and renamed.

Like Scarborough, its more prosperous neighbour to the south, Whitby developed as a Georgian spa town when three chalybeate springs were discovered. Promoted and marketed for their medicinal and tonic qualities, the curative waters drew visitors to the town, leading to the development of an embryonic tourist trade. In order to cater for the demand, lodging houses and hotels were built particularly on the West Cliff overlooking the harbour. Then, in 1839, the Whitby and Pickering Railway was built and soon extended to York. This made Whitby easily available to the growing urban communities seeking leisure and health. Interestingly, the Whitby and Pickering Railway was seen as a way to help stop the decline of Whitby's fortunes, a strategy still employed in regional regeneration today. With its main industries of whaling and shipbuilding in decline, the opening of inland transport links were designed to trigger regeneration of both town and port.

Right: Captain Cook Memorial, Westcliff, Whitby, 1955.

Below: The Piers, Spa and Gardens, Whitby, early 1900s.

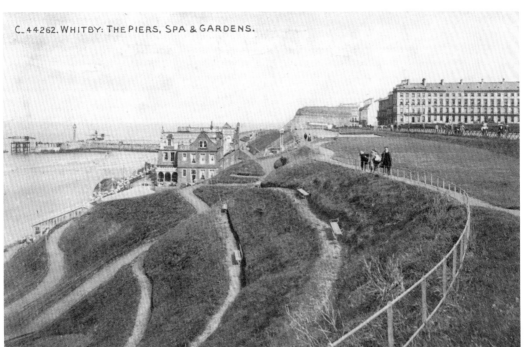

C. 44262. WHITBY: THE PIERS, SPA & GARDENS.

The Victorian developer of the partially completed Royal Crescent was a man called George Hudson, and he promoted the rail link to York. Investors had previously considered a canal link along a similar route to that eventually taken by the trains. Hudson had previously bought shares in the newly established North Midland Railway, a success that spurred him to set up his own railway company to link York with towns elsewhere in Yorkshire. He raised £446,000 and, opening as a series of stages in 1836, the line was completed on 29 May 1839, and was one of Yorkshire's first railways. However, this was a not a railway that we would recognise today, as until it linked with the York and North Midland Railway and was converted into a conventional double-tracked, steam railway in 1845, it was worked by horses. Although the line had been marketed as a way to support trade by carrying coal, stone, timber and limestone, it was also intended to carry passengers too. Three first-class coaches called *Premier*, *Transit* and *Lady Hilda* were purchased. These were essentially stagecoaches adapted for railway use and, with a number of cheap open coaches for other passengers, the line was open for business. They left Whitby at 2 o'clock in the afternoon, and returned around 8 o'clock, the company running two return journeys per day except on Sundays. As the railway network grew, conventional stagecoaches filled any gaps, and ran as feeders to smaller towns not yet connected by rail. Whitby had strong railway links with Robert Stephenson, son of George Stephenson (engineer to the Whitby and Pickering Railway), Conservative MP here for twelve years from 1847.

However, for the newly opened railway to York, things did not run smoothly and the costs were exorbitant. An official report for the shareholders, York and North Midland Railway Company, Committee of Investigation (1849) stated that,

> The original cost of the railway was £135,000, but at the time of the negotiation it was scarcely paying the expenses of working it; £30,000 was the extreme market value of the entire concern, so that the prospective increased value must have been estimated at £50,000. The line itself, it will be seen, does not pay the interest on the purchase money alone, and the enormous outlay in converting it from a Horse to an Engine line is entirely unproductive.

The Committee of Investigation noted that the costs for the Whitby branch line were:

> To purchase of Whitby & Pickering (horse) Railway, 23½ miles (£80,000) and reconstruct it for locomotives. Authorized share and loan capital £180,000. Estimated expenditure to 30th June 1849: £468,000.

Furthermore, the operating income and expenditure were summarised and did not make comfortable reading:

> Total traffic for year 1848
> Whitby & Pickering £11,323
> Working charges including depreciation, duty & rates £8,172
> Net Receipts £3,151

Clearly, Hudson was in trouble and his debtors were on his case. The Crescent remained only half built, as Hudson ran out of money and was convicted for malpractice with shareholders' money. Despite being bailed out by his friends, he never paid the money back and even retained his seat as MP for Sunderland. (Whoever said political sleaze was a new thing?)

However, Hudson did leave a lasting mark on the town and kick-started much of its future prosperity. Before the railway arrived in Whitby, transport was on foot, by horse and carriage,

by horse, or by packhorse. Trade was slow, and the town's fish catches were only taken daily as far as York, by a series of packhorse trains staging en route from pub to pub across the moors. Furthermore, Whitby was a difficult place to visit, so those desiring the healthy delights of the town or to visit as a holiday destination were more likely to go to Scarborough. In fact, until the turnpike road to Pickering opened in 1759, Whitby was better connected to the rest of the country by sea than by land. Even with the turnpike, the difficult climb over the high North York Moors was a serious barrier. Stagecoach services only began in 1795 and the thrice-weekly mail coaches ran until 1823. At this time in the early 1800s, sea air and sea bathing were delights yet to be widely discovered. They would be enjoyed by just a few determined, adventurous spirits and these travelled by horse from the immediate area.

However, the railways changed all this and Whitby became available to a rapidly growing market of holiday and health seekers. To provide accommodation required considerable building on the towering West Cliff, and to get the stone for his Royal Crescent up from the harbour, Hudson constructed the so-called Khyber Pass that winds its way directly up the steep hill. Furthermore, with York as a transport hub, Hudson's railway link to Whitby opened up the town to large numbers of factory workers from the West Riding and beyond. Day-trips became possible and affordable, and with guesthouses and hotels developed on the West Cliff, longer stay holidays were growing in popularity.

With the move away from timber ships to ironclads during the 1800s, and the development of important port facilities on the River Tees, there was a decline in the smaller Yorkshire harbours. Launched in 1871, *The Monks-haven* was the last wooden ship built in Whitby. Only a year later, the harbour was silted up, thus severely limiting access by larger vessels.

However, despite the setbacks, Whitby has always proved itself adaptable, and it began to emerge as an attractive and romantic tourism destination. Whitby became especially popular with artists, and soon both amateur and professional photographers joined them. The fishing industry and harbour, both in decline, were their key subjects. Most celebrated of the Whitby photographers was and still is, Frank Meadow Sutcliffe, and much of his work it is to be seen in the Sutcliffe Gallery in Flowergate. Sutcliffe and others captured the spirit and the industry of an age now long since gone.

Also harking back to the Victorian past, the black Whitby jet 'mourning jewellery' has once again become popular with Goths and other visitors. In Victorian England, in part following the extended mourning of Queen Victoria herself after the death of Prince Regent Albert in 1861, close relatives of the dead wore dark mourning clothes. They also wore special jewellery in dark colours and Whitby jet was ideal for this purpose. Jet is described as a lightweight 'mineraloid' and is easy to carve and polish. It is described in the Oxford English Dictionary as a 'hard compact black form of brown coal or lignite, capable of receiving a brilliant polish. It is used in making toys, buttons, and personal ornaments; and has the property of attracting light bodies when electrified by rubbing.' Essentially, jet is a soft coal measures mineral formed from the fossilised wood of a tree that grew around 135 million years ago. The finest jet in the world was mined around Whitby or else was found washed ashore on the beach. Although it was known for thousands of years, it was Victorian fashionability that produced its heyday. Jewellery of Whitby jet was especially prized for deep mourning in Victorian times and in the early nineteenth century was carved by hand. Soon, using a lathe speeded the process and the Whitby industry grew to meet the burgeoning demand. By the 1850s, there were fifty jet workshops and samples of their work were on show at the Great Exhibition of 1851. By 1873, 1,500 men worked in the trade, with 200 others mining the raw mineral. Although it is found widely across the globe, Whitby jet is now rather rare, as supplies have reduced dramatically. Jet was not universally popular, and while mourning or so-called half-mourning jewellery was still worn into the early twentieth century, it was harshly criticised by some:

If these mortuary jewels were as a whole very ugly, what shall be said of the hideous lumps of crudely manufactured jet which it is still considered by some classes of society to be necessary to wear when 'in mourning' or the even more preposterous 'half mourning' sets of ear-rings and the like, in which a little silver is introduced to lighten the effect. Whitby, which for centuries has been the seat of the jet industry, still carries on a trade in these ghoulish appendages, impervious alike to enlightenment or ridicule.

Puckle (1926)

However, today it remains popular and sought after by Goths and others in more alternative communities, perhaps for just the same reasons that Puckle disliked it. Billed as the biggest folk event of the year, Whitby Folk Week is a major annual festival with bands, callers, dance teams, storytellers and singers filling the streets and pubs. There are more than 600 scheduled events, including workshops, concerts, sing-arounds, dances, sessions, street entertainment and spontaneous fringe happenings too.

North of Whitby, Staithes is still a great draw for artists and writers. The village was home to a group of twenty to thirty artists known as the Staithes Group or the Northern Impressionists, who came to Staithes to capture the beauty of the small fishing town and the vibrancy of this coastline. The group contained renowned artists such as Edward E. Anderson, Joseph R. Bagshawe, Thomas Barrett and James W. Booth, and was inspired by other impressionists such as Monet, Cézanne and Renoir. Dame Laura Knight became the most famous member of the Staithes Group; she and her husband and fellow painter, Harold Knight, kept a studio in the village. These Northern Impressionists created their own artists' commune in the village, but with deeply held religious beliefs, if artists failed to respect the Sabbath, they were likely to have a bowl of rotting fish heads tipped over their heads to teach them a lesson. To celebrate this artistic heritage, what is now an annual event began in Staithes as a Festival of Arts and Heritage in 2012, with activities celebrating local history.

The most famous resident in Staithe's history was James Cook (born in Marton near Middlesbrough), who lived here between 1745 and 1746. He worked in Staithes as a grocer's apprentice, but soon developed a passion for the sea. William Sanderson's shop, where Cook worked, was destroyed by the sea, but parts were recovered and incorporated into Captain Cook's Cottage. Cook soon moved south to Whitby, where he joined the Royal Navy.

According to artist and writer Gordon Home (1904),

A change has come over the inhabitants of Staithes since 1846, when Mr. Ord describes the fishermen as 'exceedingly civil and courteous to strangers, and altogether free from that low, grasping knavery peculiar to the larger class of fishing-towns.' Without wishing to be unreasonably hard on Staithes, I am inclined to believe that this character is infinitely better than these folk deserve, and even when Mr. Ord wrote of the place, I have reason to doubt the civility shown by them to strangers. It is, according to some who have known Staithes for a long long while, less than fifty years ago that the fisherfolk were hostile to a stranger on very small provocation, and only the entirely inoffensive could expect to sojourn in the village without being a target for stones.

No doubt many of the superstitions of Staithes people have languished or died out in recent years, and among these may be included a particularly primitive custom when the catches of fish had been unusually small. Bad luck of this sort could only be the work of some evil influence, and to break the spell a sheep's heart had to be procured, into which many pins were stuck. The heart was then burnt in a bonfire on the beach, in the presence of the fishermen, who danced round the flames.

The Northern Parts –
Loftus & Saltburn-by-the-Sea

Almost hidden from the southern visitor by the vast massif of the high moors lies a series of small fishing settlements, and then in stark contrast, the industrial complex around Loftus. Close by the great industrial centre of Middlesbrough, the pretty seaside town of Saltburn-by-the-Sea is the most northerly resort on the Dinosaur Coast. Stand on the pier at Saltburn and you can watch the great ships that still wait out beyond the mouth of the River Tees to service the huge industrial complexes of Teesmouth on the Yorkshire coast in the shadow of the moors to the south.

The Cleveland Hills by Gordon Home:

On their northern and western flanks the Cleveland Hills have a most imposing and mountainous aspect, although their greatest altitudes do not aspire to more than about 1,500 feet. But they rise so suddenly to their full height out of the flat sea of green country that they often appear as a coast defended by a bold range of mountains. Roseberry Topping stands out in grim isolation, on its masses of alum rock, like a huge sea-worn crag, considerably over 1,000 feet high. But this strangely menacing peak raises his defiant head over nothing but broad meadows, arable land, and woodlands, and his only warfare is with the lower strata of storm-clouds, which is a convenient thing for the people who live in these parts; for long ago they used the peak as a sign of approaching storms, having reduced the warning to the easily-remembered couplet:
'When Roseberry Topping wears a cap,
Let Cleveland then beware of a clap.'
From the fact that you can see this remarkable peak from almost every point of the compass except south-westwards, it must follow that from the top of the hill there are views in all those directions. But to see so much of the country at once comes as a surprise to everyone. Stretching inland towards the backbone of England, there is spread out a huge tract of smiling country, covered with a most complex network of hedges, which gradually melt away into the indefinite blue edge of the world where the hills of Wensleydale rise from the plain. Looking across the little town of Guisborough, lying near the shelter of the hills, to the broad sweep of the North Sea, this piece of Yorkshire seems so small that one almost expects to see the Cheviots away in the north. But, beyond the winding Tees and the drifting smoke of the great manufacturing towns on its banks, one must be content with the county of Durham, a huge section of which is plainly visible. Turning towards the brown moorlands, the cultivation is exchanged for ridge beyond ridge of total desolation—a huge tract of land in this crowded England where the population for many square miles at a time consists of the inmates of a lonely farm or two in the circumscribed cultivated areas of the dales.

Loftus

Boasting a town hall clock with faces north, east and west, but none to the south since South Loftus residents would not contribute to the costs, Loftus lies between Saltburn-by-the-Sea and the North York Moors. It was formerly known as Lofthouse, and should not be confused with the other north Yorkshire town of that name. Loftus was recorded as *Lcotvsv* in the Domesday Book, from *Laghthus*, meaning 'low houses'. The area has been inhabited since at least the seventh century, and while folklore associates a house here owned by Sigurd the Dane (Siward of Shakespeare's *Macbeth*), there is evidence of ancient settlements.

As in many rural, industrial locations, the famous itinerant Methodist preacher John Wesley preached in Loftus. Ironstone mining dominates more recent history of the area and many local residents are descended from ironstone miners. As a coastal industrial site, the railway was important to the development of the town. Loftus railway station opened in 1875 and was closed to passengers in 1960 in the build-up to the Beeching cuts. The industrial line remains operative with freight services to and from Boulby Mine, and occasional passenger 'specials' as events for railway enthusiasts. Another claim to 'fame' is that north of the village there is a disused nuclear bunker, which opened in 1962 at the height of the Cold War. This short-lived facility closed in 1968.

Saltburn-by-the-Sea

Like the several other North Yorkshire seaside resorts such as Whitby and Scarborough, Saltburn was also a Victorian spa town. Saltburn-by-the-Sea is a seaside resort in Redcar and Cleveland unitary authority, and in North Yorkshire. Saltburn's attractions include a Grade II* renovated pier, which is in fact the only pleasure pier on the whole of north-east England and the Yorkshire coast. Historically part of the North Riding of Yorkshire, the town is around 12 miles (19 km) east of Middlesbrough, with a population of 5,912 at the 2001 census. By 1870, Saltburn was a fashionable resort rivalling other well-known Victorian watering places such as Harrogate and Bath. In many ways it has remained the most perfect of Victorian resorts, complete with pier, cliff tramway, miniature railway, sandy shore and leafy woodland gardens, the whole rounded off by majestic views as the cliffs tower away to the east. The town's fortunes had been boosted by the discovery of chalybeate springs, supposedly (like many others) with healing properties.

The present-day Spa Hotel was formerly the Assembly Rooms built in 1884 by a Mr T. D. Ridley of Coatham, to a design by Alfred Waterhouse of London, and was considered as one of the finest buildings of its kind. The remains of the spa and spa fountain had been incorporated into an Italian-esque garden in the 1870s. The contract for the building was awarded in February 1884 and erection must have proceeded with great speed, as, in May of the following year, a Mr A. T. Griffin was granted a licence for 'dramatic performances', though no alcohol was to be served. Attended by a 'large and fashionable audience', the opening concert was held on Friday 10 July 1885. Described as boasting commodious dressing rooms, waiting rooms and as elaborately furnished, the concert hall accommodated up to 600 people. Many touring companies performed here in the years that followed. Eventually, after it was extended and extensively 'modernised' in 1935, the building was known as The Spa Pavilion and considered as a notable asset to the town. At this time, offering 'charming views across the woodlands and cliffs to the sea', a sun lounge fitted with vitaglass was added. The pavilion had a café that provided complete shelter against inclement weather, often a necessity on the Yorkshire coast, but with sliding glass doors that opened to allow sunshine and air. At the same time, with a dance hall equipped with a fine stage and a maple-wood floor, dances were held weekly throughout the year. These were popular with locals and audiences from towns across the area. A novelty for the time when few people owned a car, the hall was proud to advertise that it had ample car parking facilities for patrons.

The town retains a strong Victorian influence due to its planning, development and architecture, and the Royal visits. Saltburn would not exist but for one man, Henry Pease. Supposedly, he built the town from scratch after an apparition of a heavenly city above the cliffs. It was in 1858, whilst walking along the coast path towards Old Saltburn to visit his brother Joseph in Marske, Henry Pease experienced a prophetic vision. This showed a town arising on the cliff with the sheltered, undisturbed wooded glen, converted turned into a beautiful garden.

With strong religious views, Pease was a Quaker industrialist whose family developed the industrial heartlands of Middlesborough. The development of Middlesbrough and Saltburn was driven by the discovery of ironstone in the Cleveland Hills, and the Errington Wood above Marske bears the scars of ironstone extraction. Income from the mines made local people such as the Pease family of Darlington very wealthy. By the nineteenth century, there were two railways to transport the minerals. Buoyed by his industrial wealth and his religious leanings, Henry set up The Saltburn Improvement Company to help translate his vision of the town into a reality, and this is significantly unchanged today. The necessary land was purchased from the Earl of Zetland, and surveyor George Dickinson was commissioned to lay out a gridiron street pattern: the necessary finance for construction was raised by selling plots to private developers and investors in the project. The intention was that as many houses as possible had sea views.

Buildings in the town were clad in hundreds of tons of distinctive white bricks, made by the Pease family factory in Durham and transported to Saltburn by the railway, which they also owned. The roof was in Westmorland slate. Henry had the Zetland Hotel constructed and this survives, but as apartments. Lord Zetland laid the foundations of the hotel on 2 October 1861, and returned for the official opening on 27 July 1863. The Zetland Hotel was one of the world's first purpose-built railway hotels that had its own private platform; though bearing in mind Salburn's capacity for wet, windy weather, a glass canopy was constructed from the railway station platform to the rear entrance of the hotel. This was to protect the guests from the inclement elements.

Marske Hall.

Early tariffs suggest that in the nineteenth century, you could get a regular bedroom for 2s 6d, running to 4s 6d for an extra-large bedroom. This may not sound a lot today, but back then, it was a substantial sum. However, you would have access to lawn tennis courts facing Dundas Street, and even the luxury of hot and cold seawater baths or freshwater baths. The hotel proved extremely popular and, in 1876, to encourage further trade, the local magistrates granted an extension of opening hours from 10.00 p.m. to 11.00 p.m. However, alcohol was not allowed to be consumed on the open terraces. Consequently, in 1882, John Richardson was fined 5s for drinking a glass of beer outside the hotel, and the hotel manager, Mr Verini, was also fined the same for supplying him.

From a visitor's handbook of 1863, the Zetland Hotel was described as,

> ...in the Italian Style ... of firebricks ... The front and sides have spacious terraces, with perforated balustrades of terra-cotta, surmounted with vases of flowers: and a neat balcony runs along the whole front of the middle storey. A semi-circular tower rises in the centre of the front, which is used as a telescope room, and is provided with another balcony; and both from the top of this tower and the balcony the view is gorgeous. The hotel contains about 90 rooms, comprising about 50 bedrooms, a large dining and coffee room, a ladies' coffee and drawing room, reading room, smoking room, billiard room etc.

By the early 1970s, the number of visitors to Saltburn was falling and upmarket hotels, in particular, struggled to survive. Like big hotels in other resorts, the Zetland Hotel closed and in 1989 was converted into apartments and the building known 'The Zetland'.

John Marius Wilson in the *Imperial Gazetteer of England and Wales* 1870–72, described Saltburn-by-the-Sea as,

> SALTBURN, a village in Brotton parish, N. R. Yorkshire; on the coast, at the terminus of the Stockton and Darlington railway, 5½ miles N E of Guisbrough. It was formerly a small hamlet, but it has acquired importance since the opening of the railway; and it has a head post-office, ‡ designated Saltburn-by-Sea, Yorkshire, a r. station with telegraph, a church, a Wesleyan chapel, and a coast-guard station. The church was built in 1867, at a cost of about £3, 200; consisted then of nave, N aisle, and N transept; was designed to be enlarged with S aisle, S transept, chancel, porch, and vestry, and to have a tower and spire 100 feet high; and is in the early decorated style, more French than English. The Wesleyan chapel was built in 1865, and is in the early English style.

The Redcar to Saltburn Railway opened in 1861 as an extension of the 1846 Middlesbrough to Redcar Railway, and extended to Whitby as part of the Whitby Redcar and Middlesbrough Union Railway.

High Hills, Wild Cliffs & Coastal Flatlands

The coastline at Saltburn lies practically east–west, and along much of it runs Marine Parade. To the east of the town is the imposing Hunt Cliff, topped by Warsett Hill at 166 metres (545 foot). Skelton Beck runs through the wooded Valley Gardens in Saltburn, then alongside Saltburn Miniature Railway, before being joined by Saltburn Gill going under the A174 road bridge and entering the North Sea across the sandy beach.

Gordon Home described the view looking northwards from near Staithes.

> Looking northwards, there is a grand piece of coast scenery. The masses of Boulby Cliffs, rising 660 feet from the sea, are the highest on the Yorkshire coast. The waves break all

round the rocky scaur, and fill the air with their thunder, while the strong wind blows the spray into beards which stream backwards from the incoming crests.

Migrant Birds & Abundant Nature

The spectacular Hunt Cliff and Warsett Hill dominate east of Saltburn, the rugged sea cliffs supporting good numbers of breeding seabirds particularly kittiwakes, cormorants, herring gulls and fulmars. The cries from the seabird colonies and the smell of the sea lend a particular character to summer that part of Saltburn. The lower cliffs and rocks support breeding rock pipits and outside the breeding season, these turn up further north along the seafront. The walks here provide plenty to see throughout the year in terms of wildflowers, insects such as butterflies, including clouded yellows and a resident population of common blues, and the occasional roe deer. Other migrant insects have included convolvulus hawkmoths, hummingbird hawkmoths, and silver Y moths in abundance. As a prominent coastal promontory on coastline and estuary with good numbers of passage birds, the area gets some interesting and exciting species, such as red-flanked bluetail recorded by local expert, Damian Money. The area has plenty of birds, breeding, wintering and migrating.

Key sites include Little Dale rising up from behind the Ship Inn, the Gill itself (the valley of the Skelton Beck), Crane Dale, further along the cliffs, and indeed all the hillsides cloaked with dense blackthorn, hawthorn and gorse. Little Dale has had rarities like Pallas's and yellow-browed warblers, red-breasted flycatchers, and throngs of commoner migrants such as redwings and goldcrests. Stonechats, which love areas of gorse and bracken, can be seen at any season. Exciting birds have included long-eared owls, short-eared owls, firecrest, black redstart, great grey shrikes and red-backed shrikes, wryneck, water rail, Richard's

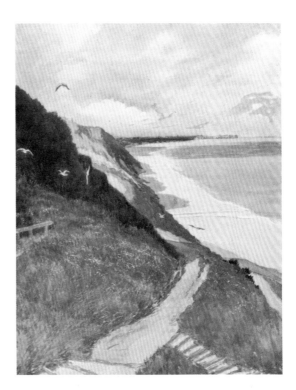

The coast at Saltburn from Gordon Home, 1904, *Yorkshire Coast and Moorland Scenes.*

pipit, shore lark, barred warblers and more. Overall, in many ways this is a typical East Coast landscape with the potential to turn up remarkable species, providing someone is sufficiently dedicated and knowledgeable to spot them. A clifftop location, dense areas of scrub and a situation close to a major estuary make it rather special.

If weather conditions are suitable, then at the right time of year, the large numbers of migrant turn up both during spring and autumn passage. However, this is not just a landscape for odd and unusual birds, with rough ground between the cliffs and the adjacent farmland, bird species include grey partridges, red-legged partridges, yellowhammers, chaffinches, skylarks, tree sparrows, goldfinches and linnets. Like many such landscapes along the East Coast, the now uncommon corn bunting was once typical of the open farmland areas. It is apparently some years since they bred here. Winter brings a huge influx of birds from colder climates in northwest Europe, with redwings, fieldfares, blackbirds, robins and exotic-looking waxwings.

History, Heritage, Industry & Seaside Charm

English racing driver Sir Malcolm Campbell (11 March 1885 – 31 December 1948) set his first speed record (138.08 mph – unofficial) while driving Blue Bird on Saltburn Sands on 17 June 1922. He was a motoring journalist, and reputedly, a fascist sympathiser who broke the

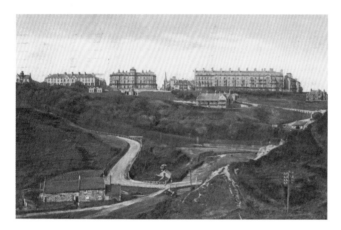

Hunt Cliff, Saltburn-by-the-Sea, 1936.

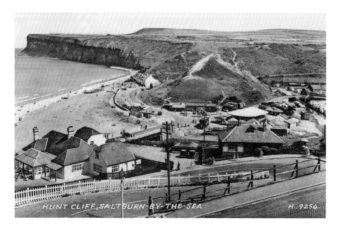

Hunt Cliff, Saltburn-by-the-Sea.

world speed record on land and on water at various times during the 1920s and 1930s, using a number of vehicles called *Blue Bird*. Saltburn also contributed to modern British culture as the childhood home of David Coverdale, lead vocalist for Deep Purple and Whitesnake. He grew up in the Red Lodge (now Red Gables) on Marine Parade.

The house Teddy's Nook was built in 1862 by Henry Pease, as his own residence and this solidly constructed sandstone house was simply called The Cottage. Prince Edward (later Edward VII) had a suite of rooms at the Zetland Hotel, and his mistress Lillie Langtry (The Jersey Lily), stayed at the house at times between 1877 and 1880. Often visited by Prince Edward, the cottage was known as Teddy's Nook.

Old Saltburn was the original settlement and was located at the bottom of the Saltburn Gill. This was a tiny hamlet with little known of its early history except that it was a centre for smugglers. The sometime publican of the Ship, John Andrew, was reputedly the 'king of smugglers'. By 1856, the hamlet was made up of the Ship Inn and a row of cottages occupied by farmers and fishermen. In the mid-eighteenth century, authors Laurence Sterne and John Hall-Stevenson enjoyed racing chariots on the sands at Saltburn. Nowadays, the North Riding Duck Race is held each year on 1 August to celebrate Yorkshire Day. The winner receives the Colin Holt Cup, named in honour of the late Colin Holt, for many years the chairman of the Yorkshire Ridings Society. A prize is given also for the duck with the most original name.

The Victorian resort of Saltburn-by-the-Sea still lives on today, with Britain's oldest water-based cliff lift still in operation. The Saltburn cliff lift transports passengers up and down the 120-foot embankment to the sea front, Saltburn's famous Victorian Pier and town centre. Indeed, it was after the opening of Saltburn Pier in 1869 (now a protected structure), it was felt that the steepness of the road up the cliff deterred visitors from walking between the town and the pier. With this in mind, a wooden cliff hoist was constructed and opened in July 1870. This rather rickety structure was made of wood, fastened down by guy-ropes, and around 120 feet high. This allowed up to twenty people at a time to descend or ascent the cliff in a cage. Approached by a narrow walkway at the top, the system operated by means of a tank filling with water to counterbalance the weight of the cage and its passengers. The charge was one half-penny a head, though the machine had the disconcerting habit of sticking partway up. After responsibility passed to Middlesbrough estates in 1883, it was discovered to have rotten supports and the original structure was demolished.

The present cliff tramway developed by Sir Richard Tangye, whose chief engineer was George Croydon Marks, was opened a year later, probably in June 1884, and, providing transport between the pier and the town, is one of the oldest water-powered funicular railways in the world. It was the third structure of its kind in Britain, the first two being in Scarborough. Since 1924, the water pump has been operated electrically and major maintenance carried out in 1998, replaced the main winding wheel and the braking system installed.

Today, Saltburn retains all of the charm and elegance of its heyday as a thriving Victorian resort. The Smugglers Heritage Centre details the history of the once prospering smuggler trade along this beautiful coastline. August sees the annual International Folk Festival welcoming visitors from around the world to celebrate through music, dance and song.

Beyond Saltburn, to the north, are the vast areas of intensive industrial Middlesbrough, the huge estuary of the River Tees, and then the mix of industry and seaside that makes up Tyneside. However, all that is beyond the North York Moors and most lies outside of Yorkshire.

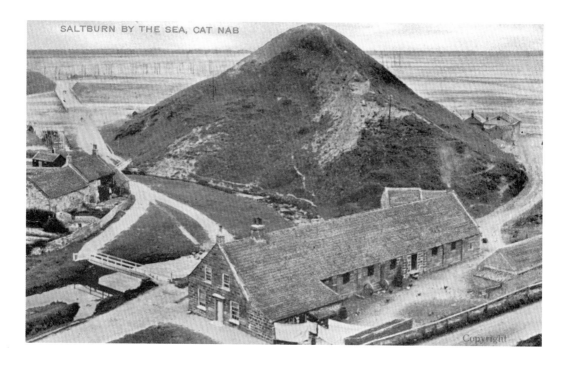

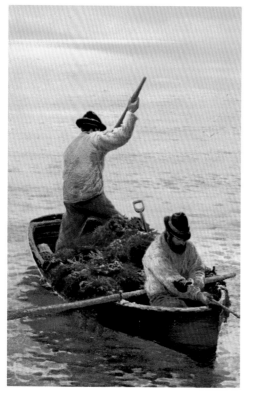

Above: Cat Nab, Saltburn-by-the-Sea, early 1900s.

Left: East Coast fishermen.

A typical North Yorkshire farmer by
Gordon Home, 1908.

farmsteads and small villages with the distinctive red bricks and red-tiled roofs.
Twentieth-century forestry has also been important here and the dark, sombre shrouds
of conifer plantations dominate many upland scenes. Today, these planted, exotic
woodlands provide shelter for roe deer and other wildlife. The inland areas of the Vale
of Pickering and the long tongues of the valleys that extend north into the moorland
massif are good places for the lover of nature. The sheltered valley woodlands and
grasslands are home to nationally famed populations of wild daffodils, but also to
deer and wildflowers of woodland and grassland. On the higher ground, the visitor
emerges onto the vast, expansive moors and bogs, at once a cultural landscape and a
place to experience wild nature. Here, the lowland pheasant and partridge give way
to the red grouse, that most evocative upland bird. Inland and high above Pickering
through to Whitby and beyond, the vast expanse of the North York Moors dominates
landscape and people alike. Dedicated enthusiasts have also restored and run the North
York Moors Railway and this adds another layer to the rich tourist experience of the
region.

Sandstones, Shales & Peat

To the east of the great moorland high ground, the area is clearly defined by the North
Sea coast and massive cliffs. The main valley running from the North York Moors massif
is that of the River Esk, Eskdale. The river flows from west to east and discharges into the
North Sea at Whitby. The underlying geology, which dominates the coastal moors, is a mix
of shales and ironstone, with most of the area being Ravenscar sandstone. This latter rock
produces free-draining soils and acidic, low-nutrient conditions ideal for Heather moorland.
Some of the lower areas have alluvium and glacial deposits that can influence drainage and

nutrient levels. Topographically, much of the coastal belt of moorland is flat and expansive, and in the east slopes gently down towards the North Sea.

This geology and topography has influenced the moors themselves, with the huge expanses of heather moorland. In addition, however, they have determined the settlements and the people too. Transport has been difficult due to the terrain and hamlets, villages, and even towns have been relatively isolated. The geology has bred communities able to adapt to the harshest environments and indeed to thrive within them. The moorland farmers have had to be resilient and tough.

As the land drops gently eastwards, valleys have been cut into the landscape, as streams become rivers. These valleys leave the moors behind and lead into the farmland and then the seashore, notably at Robin Hood's Bay, Ravenscar and Tan Beck, Hayburn Wyke, and at Cloughton. The lower lands have been easier to cultivate and many have been settled for centuries or more. However, in some places, the land to the seawards is rougher and extreme, so here and there, especially on higher clifftops, areas of heath and gorse spread upwards as they once did, to join with heather moors of the higher ground.

The communities of the lower grounds have traditionally exploited the higher moors as well. Mostly forgotten today, but many settlements relied on peat and turf cut from moor and bog for their fuel. Scarborough itself was fuelled by peat turf, originally from the site of what is now The Mere, but also from a peat pit close by the Falcon Inn on Whitby Road near Cloughton.

Barnby Moor above Whitby by Gordon Home, 1908.

Goathland Moor by Gordon Home, 1908.

Grouse Moors by the Sea

Hard sandstones erode only slowly and form nutrient poor acid soils. With high levels of rainfall, the acidic soils reduce permeability, impeding drainage and this encourages the tendency to form peat bogs. With cold acidic waters of peat bogs, with little free oxygen gas, there is only limited decomposition of organic material so dead moss and other vegetation accumulates to form peat. Cotton grass, sphagnum moss, rushes and purple moor grass tend to dominate these wet areas, and sphagnum in particular can help the active growth of peat. Growth of sphagnum and a build-up of peat raise the level of a bog and it may dry out, leading to invasion by heather and other species of drier conditions. These same species tend to dominate the drier areas of moor that have only thin peats and so extensive areas are covered in heather, bilberry and grasses. Some of these are on thin peats and others are on thicker, former bogs.

The thicker peats and the thin heathy areas have both been exploited for peat and turf fuel over many centuries. The local communities on the moors, as well as those in surrounding towns and villages, did this. Almost all traditional peat cutting has now ceased, and the Saltersgate Inn, with its own turbary and peat-burning range, has now closed. Peat cutting has had a huge influence on the ecology and landscape of the moors.

The wildlife is directly affected by the harsh conditions of geology, climate and acidic soils. An example is that heath and peat bog are unsuitable for earthworms, so that animals normally feeding on these are absent. Mammals such as moles and common shrews do not occur on the moors, except perhaps along the roadsides with their neutral grasslands, but by eating insects and spiders living in the heather, pygmy shrews do survive. The moors and bogs are good habitat for breeding lapwings, curlews, redshanks, wheatears, meadow pipits, skylarks, common snipe, and golden plovers. Common sandpipers are found along streams and rivers, and the upland blackbird, the ring ouzel breeds on stony and rocky escarpments.

Perhaps the ultimate bird of these moors is the red grouse, which is mostly herbivorous, feeding on young heather shoots, other vegetation and some invertebrates. Management of the vegetation by, and for, sheep, and for red grouse, dominates much of the moorland landscape. Gamekeepers and farmers burn heather in strips or patches, which encourages new, young, heather growth to feed the grouse. In upland areas like the moors, bracken fern is extremely invasive. Formerly an important crop to be harvested and used, land management has changed over the last 200 years, and the bracken has spread to dominate many areas.

The Seaside Farmers & the Moorland Keepers

An account of the social history of the moors is a different book, but it is worth noting some distinctions and differences from the other areas. The moors are used by a scattered population, a community of small farms and cottages, of farmers and gamekeepers and today, of holidaymakers. People live in the lower ground in the shelter of the valleys and the lower slopes. Throughout history, the hamlets, villages and towns of the area have needed and even relied upon the seasonal products of the moorland plateaux. Even today, the moors provide the vital economic mainstays of the region with the hugely important tourism industry, the sports shooting of game, and the traditional farming occupations of the countryside.

Right: In Mulgrave Wood above Sandsend by Gordon Home, 1908.

Below: Red grouse by Whymper.

A Remarkable Heritage –
Some of the Main Sites and Places

This final chapter introduces and illustrates some of the places and sites to visit, such as castles, houses, halls, parks, estates, nature reserves, churches, abbeys, museums and other locations across the region. Most of all, this region has some of the finest recreational walking countryside in Britain. The two major trails are the Cleveland Way, the coastal path, and the Coast to Coast Path, Alfred Wainwright's unofficial route that terminates at Robin Hood's Bay. In the south part of the coast, Filey is the eastern and southern end of the Cleveland Way, the north end of the Yorkshire Wolds Way National Trail, and the eastern destination of the Great Yorkshire Bike Ride from Wetherby. Inland, around the North York Moors in particular, there are abundant footpaths, cycleways and hidden lanes to suit all tastes.

North Yorkshire and the Dinosaur Coast are covered by a network of informal access routes, but there are particular locations that are especially attractive to visitors. These famous attractions include Filey Brigg, the coastal walk north of Sandsend, south of Saltburn, and indeed along the coastal path near all the settlements described in the chapters of this book. However, the area has wonderful walks in and around the major towns too. The walk around the Scarborough Castle headland, for example, or up the famous 199 steps at Whitby to the church and abbey, are essential experiences for the visitor. Wherever you are along the Dinosaur Coast, from the town to the countryside, there are gorgeous walks to be enjoyed. The local seaside towns and villages have already been introduced, and they all have much to offer and each is different and special. The summary below is by no means definitive, but just a flavour of what is on offer.

The Towns

Filey: beaches, boats, clifftop walks, seafront, old town, old church, shops, amusements, restaurants, cafés, pubs, hotels & wildlife.

Scarborough: extensive leisure facilities, university, castle, theatres, cinema, museums, galleries, beaches, boats, clifftop walks, seafront, old town, old church, shops, amusements, fun-fair, restaurants, cafés, pubs, hotels, gardens and parks, and wildlife.

Robin Hood's Bay: galleries, beaches, boats, clifftop walks, old town, old church, shops, restaurants, cafés, pubs, hotels, and wildlife. Perhaps one of the most popular, charming, picturesque fishing villages in the country, Robin Hood's Bay lies six miles south of Whitby in North Yorkshire. A mile south of the village are Bronze Age burial mounds called Robin Hood's Butts, and there are signs of Roman occupation, Ravenscar once a Roman Signal Station.

Whitby: extensive leisure facilities, abbey ruins, old church, youth hostel, theatre, museums, galleries, beaches, boats, seafront and walks, old town, shops, amusements, restaurants, cafés, pubs, hotels, gardens and parks, and wildlife.

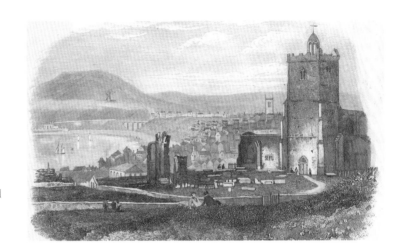

St Mary's church and view of the town of Scarborough, early 1800s.

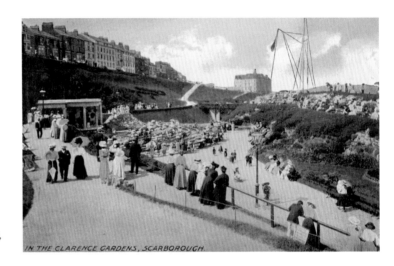

The Clarence Gardens, Scarborough, 1911.

Sun Lawn and Boating Lake at Butlin's, Filey, 1960.

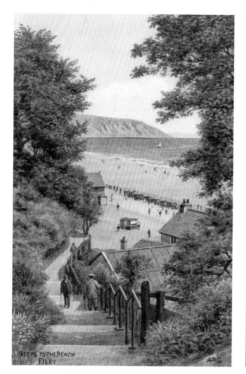
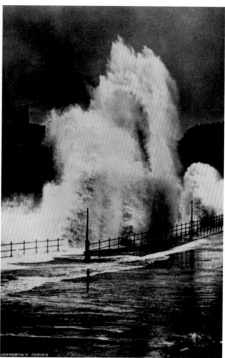

Above left: The steps down to the beach at Filey, early 1900s.

Above right: Record wave, Scarborough, 1911.

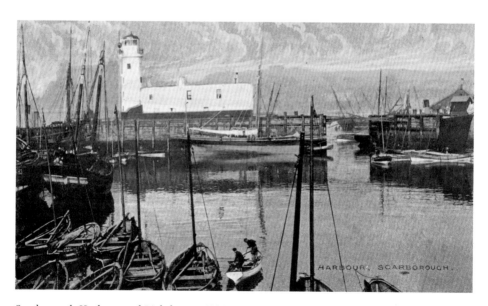

Scarborough Harbour and Lighthouse, 1904.

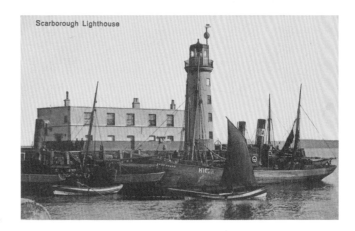

Scarborough Lighthouse, 1915.

Scarborough NER poster, 1910.

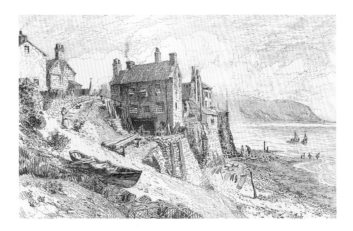

Robin Hood's Bay from
Leyland, 1892.

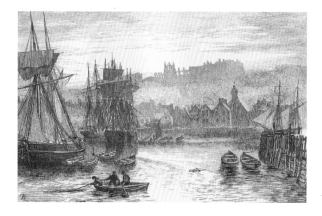

Whitby from Leyland, 1892.

Whitby Old Town, early 1900s.

Sandsend: Located at the foot of Lythe Bank Sandsend is a picturesque village with cottages set against a backdrop of cliffs and two meandering streams, which lead to the sandy beach.

When you enter Sandsend, you cannot fail to be impressed by the magnificent sweep of the bay leading to the majestic ruins of Whitby Abbey in the distance. Sandsend is a delightful village with pubs and cafés dotted along the sea front. Walking along the beach, which stretches 3 miles to Whitby, you will often see surfers on their boards, making the most of the waves.

Staithes: North of Sandsend is Staithes, a charming picturesque fishing village, which remains unspoilt by time. Its cobbled streets, narrow alleyways, pantile roofed houses and fishing cobles moored in the beck attract visitors all year round. As staithe is an old English word meaning 'landing place', and Staithes was so named because it had two, one on either side of Roxby Beck. Staithes was once one of the largest fishing ports on the North East coast, as well and an important source of minerals such as jet, iron, alum and potash. Today, the village with its huddle of cottages nestled between towering cliffs is a very attractive holiday destination.

Runswick Bay: Situated 5 miles north of Whitby, Runswick Bay is a picture-postcard seaside village loved by both artists and holidaymakers. The village is split into two parts – a number of houses at the top of the cliffs contrast sharply with the red-roofed cottages that appear to tumble down the cliffside to the seafront below. The beach can be accessed via a steep 1 in 4 road with an accessible car park at the bottom.

Staithes' Beck Mouth, early 1900s.

The Staith, Whitby, 1914.

Saltburn: galleries, beaches, boats, clifftop walks, seafront, old town, shops, restaurants, cafés, pubs, hotels, gardens and parks, and wildlife.

Some Specific Places to Go
The region is also rich in terms of individual places to visit; the following are a selection:

Whitby Abbey: In AD 657, founded as Streanshalh (signifying Fort Bay or Tower Bay in reference to a supposed Roman settlement or Roman Signal Station that previously existed on the site), by Oswy the Saxon King of Northumbria. Whitby Abbey, with its gaunt, imposing remains, set high on a cliff above the town, was recently named Britain's most romantic ruin.

Over centuries, the location has been a bustling settlement, a king's burial place, the setting for a historic meeting between Celtic and Roman clerics, the home of saints including the poet Caedmon, and inspiration for Bram Stoker, author of *Dracula*. The museum & interactive visitor centre displays show fascinating finds from the Anglo-Saxon, medieval and Cholmley periods, and tell the stories of this remarkable site. Whitby Abbey, Abbey Lane, Whitby, YO22 4JT; 01947 603568; http://www.english-heritage.org.uk/daysout/properties/whitby-abbey/.

Cholmley House or Whitby Hall: This banqueting house next to the ruins of Whitby Abbey was built by Sir Hugh Cholmley for £232,000 in 1672. His family had gained

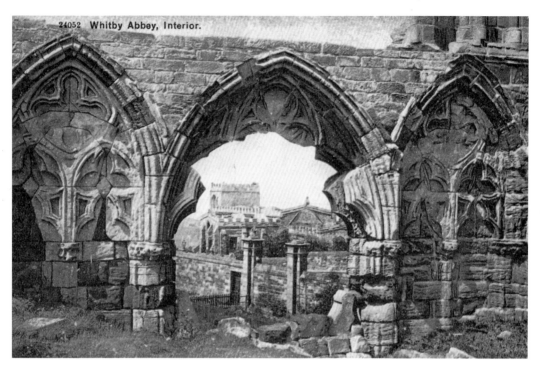

Whitby Abbey interior.

the Abbey ruins and the surrounding land after its dissolution in 1539. Until 1672, the family lived in Abbey's former gatehouse and guest lodgings. Originally built as a square with a square courtyard in front of it (the Stone Garden) with a replica of the Borghese Gladiator. In 1743, when the family succeeded to the Wentworth estates and moved to Howsham Hall, Cholmley House was deserted. On this exposed location, the north front lost its roof in a storm in 1790, and was demolished. Only the main hall remained and this was dilapidated. In 1866, new owners, the Strickland family, had bracing arches built to secure its walls. Then, in 1936, the Ministry of Works took over the house and abbey ruins, transferred to its successor English Heritage in 1984. The house reopened in 2002 as the museum, shop and visitor reception for the Abbey site.

Abbey House, Whitby: Formerly Whitby Manor House, the Abbey House is at the rear of St Mary's Church on East Cliff and supposedly occupies the site of the Abbot's house. In 1580, Sir Francis Cholmley, son of Sir Richard, built the oldest part of the mansion in part from the ruins of the Monastery. Around 1635, Sir Hugh Cholmley greatly enlarged and improved the building. Today the house is YHA Whitby, with low-cost visitors for school trips, walking, cycling and the old town of Whitby. Habit House, East Cliff, Whitby, YO22 4JT; 0845 371 9049; http://www.yha.org.uk/hostel/whitby.

Whitby Pavilion Complex & Whitby Digital Cinema: Situated on the cliffside overlooking Whitby Bay, this unique venue offers a range of different spaces and a host of events. The Pavilion Theatre with its atmospheric Victorian interior, combines with modern dance and concert hall, to host arts and leisure activities such as stage shows, dances, major festivals &

concerts, fund-raising and children's events, exhibitions and conferences. The glass atrium and café has stunning panoramic sea views from Sandsend Nab to Whitby's East and West Piers. West Cliff, Whitby, YO21 3EN; 01947 458899; http://www.whitbypavilion.co.uk.

Art Gallery & Whitby Museum, Pannett Park: Museum opens throughout the year and with collections relating to the Jurassic fossil coast, and to the whaling and fishing industries. Pannet Park, Whitby, North Yorkshire, YO21 1RE; 01947 602908; email keeper@whitbymuseum.org.uk.

Whitby Lighthouse: The lighthouse, operated by Trinity House, rated as one of the top tourist attractions in Whitby, is a white octagonal brick tower designed by James Walker, and built in 1858. It is on Ling Hill, southeast of Whitby, beyond Saltwick Bay. Originally, it was one of a pair of towers aligned north-south and known as the High Light and the South Light. Their purpose was to show fixed lights over Whitby Rock just off and to the south of Whitby Harbour entrance, but in 1890, with a more effective light installed in High Light, South Light was deactivated.

The Dracula Experience: The Dracula Experience is a unique tour through the Dracula story connection to Whitby. In 1885, the Russian schooner The Demeter ran aground in Whitby harbour on Tate Hill Sands during a wild storm; mysteriously all the crew were dead, including the captain, who was lashed to the helm. As the ship ran aground, a huge black dog was seen leaping ashore and running up the steps towards Whitby Abbey. Stoker's Count Dracula had arrived in England... Marine Parade, Whitby, YO21 3PR; 01947 601923/01; email rudi@terrortower.co.uk; http://www.draculaexperience.co.uk/.

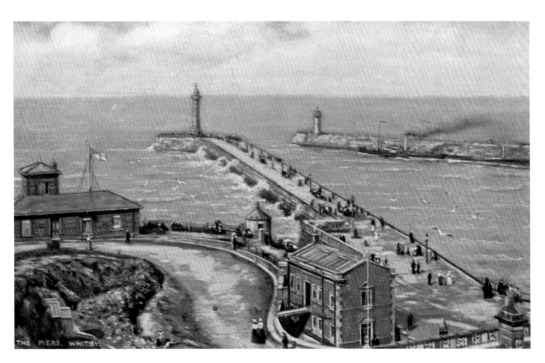

The piers at Whitby, early 1900s.

Captain Cook Memorial Museum, Whitby: In 1746, this handsome seventeenth-century harbourside house was where the great explorer, James Cook, served his apprenticeship in Whitby. Cook's master was Captain John Walker the Quaker ship owner. As a young man, when Cook was not at sea, he lodged here in the attic with other of apprentices. Now a museum, it houses a superb collection of original exhibits about Yorkshire's most famous son. Grape Lane, Whitby, YO22 4BA; 01947 601900; email whitbycookmuseum@tiscali. co.uk; www.cookmuseumwhitby.co.uk.

Whitby Whale Bone Arch: A thousand years of ecclesiastical and maritime heritage are preserved in the historic port of Whitby. Fine houses, secret courtyards, alleys and ghosts remain to be discovered with the storywalker who, dressed in character costume will tell you stories and answer your questions. For Whitby Walks - Ghosts & Dracula: 01947 821734; email harry@whitbywalks.com; www.whitbywalks.com.

Scarborough Castle: The ancient and dramatic Scarborough Castle is one of the most important historical sites in Yorkshire with a major role in Scarborough's history and one of the finest tourist attractions in northern England. Once the glory, and still the ornament of Scarborough, it was built by William le Gros in the reign of King Stephen, but the site, with its stunning location and panoramic views, has a 3,000-year history. It began as an Iron Age Fort, was later occupied by the Romans, was then a Viking settlement, and reached its zenith with Henry II. Added to by successive medieval kings over two centuries, Scarborough was an important royal stronghold and so experienced numerous sieges and conflicts, from the English Civil War to the First World War. English Heritage, Castle Road, Scarborough, YO11 1HY; 01723 372451; 0870 333 1181; http://www.english-heritage.org.uk/daysout/properties/scarborough-castle/.

Oliver's Mount: Oliver's Mount, with its impressive 75½-foot War Memorial, is a large wooded hill rising to 500 feet above sea level, overlooks the southern part of Scarborough and offers stunning views of Scarborough and beyond. The former name of the hill was Weaponness and its modern name may be because of the mistaken belief that Oliver Cromwell put gun batteries here during the siege of the Castle. Today it has an attractive picnic area.

Scarborough SEA LIFE Sanctuary: The themes of the sanctuary take visitors on a journey from the coast to the ocean depths twelve zones, including an underwater world filled with diverse and amazing sea creatures. From close encounters with sharks to hands-on rock-pool experiences, there are penguins, seals and otters. The Seal Hospital for over thirty rescued seals every year shows how they are nursed back to health and safely returned to the wild. Scalby Mills, Scarborough, YO12 6RP; 01723 373414; www.sealife.co.uk/scarborough.

William Smith Museum of Geology, Rotunda Museum: The Rotunda is the second oldest purpose-built museum in Britain. Built in 1828, to the specifications of William Smith, the father of English geology, the museum has long-been a focal point for geology and local history enthusiasts. Following major investments and a two-year re-fit, the museum now encompasses all the interactive technologies demanded of a modern museum. At the same time in the central Rotunda Gallery, you will find a remarkable space that explains the Scarborough that existed in Smith's time and some of the town characters from the period. Vernon Road, Scarborough, YO11 2PS; 01723 353665; www.rotundamuseum.co.uk.

Scarborough Art Gallery: This Italianate villa was built in the 1840s as part of The Crescent. Today, it houses Scarborough's fine art collection with paintings featuring seascapes and

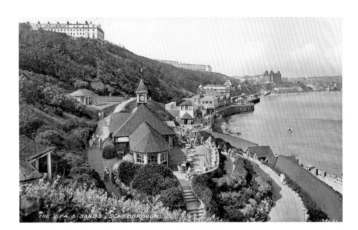

The Spa and Sands,
Scarborough, 1920s.

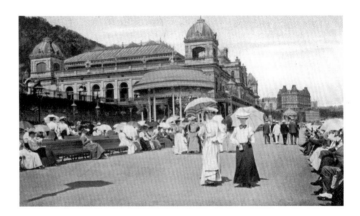

The Spa Pavilion,
Scarborough, 1905.

views of Scarborough, including works by Atkinson Grimshaw, H. B. Carter, Frank Mason and Ernest Dade. The gallery also displays works by Lord Leighton, Ivon Hitchens, Matthew Smith, Edward Bawden and Eric Ravilious. The gallery has a lively temporary exhibition programme that features contemporary work by professional artists. Our programme also includes talks and holiday activities for families. The Crescent, Scarborough, YO11 2PW; 01723 384503; email info@smtrust.uk.com.

Stephen Joseph Theatre: The Stephen Joseph Theatre is home to Alan Ayckbourn, the world's most performed living playwright and boasts two auditoria: The Round and The McCarthy, the latter also doubling as a cinema. Westborough, Scarborough, YO11 1JW; 01723 370541; email enquiries@sjt.uk.com; www.sjt.uk.com.

Peasholm Park: park with lake, islands, café and other attractions. North Bay, Scarborough, YO12 7TR.

Vincent's Pier & Lighthouse: The Vincent Pier is a Listed Structure owned by Scarborough Borough Council built in 1752 and with a lighthouse at the end. In 1914, during the bombardment of Scarborough by German cruisers, the lighthouse was badly damaged and the tower dismantled, rebuilt in 1931. Sandside, Scarborough, North Yorkshire, YO11 1PG.

South Cliff Italian Gardens: Designed in the early twentieth century, the Italian Gardens were by noted landscaper Harry W. Smith. The sheltered Italian gardens feature formal planting, seating and a fishpond overseen by the winged messenger, Roman God, Mercury. Esplanade, Scarborough, YO11 2AY; www.italiangardens.co.uk.

Scarborough Star Disk: This is at the site of the old South Bay Pool. The largest illuminated 'Star Disk' in the UK, and possibly in Europe – 26 metres in diameter. Constructed on the site of the South Bay Pool, the disk contains fibre-optic terminals representing the forty-two brightest circumpolar stars (stars that never set) as seen from Scarborough. It also marks the position of the sunrise points over the North Sea for various dates of the year. Scarborough Star Disk, Old South Bay Pool Site, South Bay Promenade, Scarborough, YO11 2HD; www.scarborough-ryedale-as.org.uk/saras/scarborough-star-disk/.

Military Adventure Park & Crazy Combat: An outdoor activities and theme park. Peasholm Gap, Scarborough, YO12 7TP; 0844 4127457; email info@crazycombat.co.uk.

Robin Hood's Bay & Fylingdales Museum: The building is the old Coroner's Room and Mortuary, and on 31 July 1891, Revd R. J. Cooper, Vicar of Fylingdales Parish, purchased the building on a thousand-year lease, and paid to convert the downstairs room into a coroner's Room, with a mortuary built against its east wall. After 1900, it was a reading room for local people though still available, if needed, as a mortuary. With newspapers, periodicals and books provided, the reading room and library flourished for a long time, but closed in 1987. By 1980, a newly-formed Museum Trust had temporary exhibitions in the coroner's room, the displays have developed and expanded since then.

Filey Bird Garden and Animal Park: Opened in 2008, this family-run park has been attractively designed to create a visitor attraction that appeals to people of all ages and abilities.East Lea Farmhouse, Scarborough Road, Filey, YO14 9PG; 01723 514439; email franholah@fileybirdgarden.com; www.fileybirdgarden.com.

Filey Museum: This is in Queen Street, in the old town away from the shopping areas and close to the twelfth-century St Oswald's church. The museum buildings are from the seventeenth century, formerly a fisherman's cottage and a farm cottage. In the late 1960s, the now Grade II listed buildings were saved from demolition, and a local history museum opened in 1971. Nos. 8/10 Queen Street, Filey, YO14 9HB; 01723 515013; email contact@fileymuseum.co.uk; www.fileymuseum.co.uk.

Country Park, Filey: Here at Country Park is car parking and access to clifftop walks and views. There is a play park, a miniature golf course, a small café and a campsite for tents and caravans. Country Park, Church Cliff Drive, Filey, YO14 9ET; 01723 383636.

Glen Gardens, Filey: The peaceful Glen Gardens offer a retreat for family picnics with an open-air boating lake, and a traditional play park. Glen Gardens, West Avenue, Filey, YO14 9JL; 01723 383636.

Memorial Gardens, Filey: The Memorial Gardens are located in the heart of Filey, an ideal location to relax and lunch. The romantic fountain and the exotic singing birds provide an escape from the hustle and bustle of the busy town. Murray Street, Filey, YO14 9DA; 01723 383636.

Crescent Gardens, Filey: The Crescent Gardens offer stunning views across the bay and in summertime there are brass band concerts in the newly built bandstand. The Crescent, Filey, YO14 9HZ; 01723 383636.

Primrose Valley: Holiday Park owned by Haven Holidays, around three miles south of Filey, just off the A165. The Park is promoted as a flagship park, and as one of the largest of its kind in the country. Primrose Valley, Filey, YO14 9RF; 01723 513771; www.haven.com/parks/yorkshire/primrose-valley/.

Geology and History Trail at Filey Brigg: This rocky headland is a Site of Special Scientific Interest because of its geological importance and is designated as a Local Nature Reserve.

Scampston Hall & Scampston Walled Garden: This country house has remained in the same family since it was built towards the end of the seventeenth century and now houses an important collection of art works. The architect Thomas Leverton extensively re-modelled it in 1801 with fine Regency interiors. Dogs may be taken for a walk in the park and the restaurant and plant sales are free to enter. There is disabled access to the garden and all visitor facilities. Scampston, Malton, YO17 8NG; 01944 759111; email info@scampston.co.uk; www.scampston.co.uk.

Eden Camp Modern History Theme Museum: Housed in an original Prisoner of War Camp, this award-winning museum takes you back in time to wartime Britain. Visitors experience the sights, sounds, and even the smells of both Home Front and Front Line. Part of the museum covers the Blitz, the Street at War (with rationing and fashions), the Home Guard, Evacuation, the Battle of Britain and VE & VJ Day. World conflicts and battles are featured elsewhere. The Museum houses a large display of military vehicles and equipment including tanks, artillery pieces, aircraft, mini submarines, air raid shelters and a Prefab. Junction of A169, Malton, YO17 6RT; 01653 697777; admin@edencamp.co.uk; www.edencamp.co.uk.

Pickering Castle: Set in the attractive moorland-edge market town of Pickering, this splendid thirteenth-century castle has been a royal hunting lodge for a succession of medieval kings, a holiday home, and a stud farm. English Heritage, Castlegate, Pickering, North Yorkshire, YO18 7AX; 01751 474989; 0870 333 1181; www.english-heritage.org.uk/daysout/properties/pickering-castle/.

Wheeldale Roman Road: South of Goathland: West of A169 and seven miles South of Whitby, this mile-long stretch of enigmatic ancient road is probably Roman but possibly later or earlier. It is set amid wild and beautiful moorland, still with its hard core and drainage ditches. English Heritage: 0870 333 1181; www.english-heritage.org.uk/daysout/properties/wheeldale-roman-road/.

Gisborough Priory: The Priory of St Mary of Gisborough was formally dissolved in 1540 during the reign of Henry VIII. By 1550, the Chaloner family had bought the site and buildings and still own the site today. A triumphal arch sits admirably in the market town of Guisborough. The east end of the priory church is an outstanding example of Gothic architecture and a reminder that this was once a very wealthy monastery, a sanctuary from busy market day shopping. The priory was the fourth wealthiest religious house in Yorkshire at the time of the dissolution. Today it is cared for by English Heritage and is a scheduled ancient monument. Church Street, Guisborough, TS14 6HG; 01642 496418; www.gisboroughprioryproject.co.uk.

Staithes Gallery: This galley is in the picturesque fishing village of Staithes, long a magnet for art and artists. The gallery aims to provide a showcase right in the heart of the old village for the very best contemporary artwork inspired by Staithes and the surrounding area. The exhibitions reflect the quality and variety of art stimulated by this most inspirational of villages. The gallery is home to Staithes Art School, where painters at all levels can develop their skills alongside professional artists and be inspired by the spectacular land and seascapes that drew generations of artists to this wild and beautiful part of the coast. High Street, Staithes, TS13 5BH, 01947 841840; email al@staithesgallery.co.uk; www.staithesgallery.co.uk.

Hole of Horcum: The Hole of Horcum is a section of the valley of the Levisham Beck in the North York Moors of northern England, upstream of Levisham and Lockton.

The Old Coastguard Station, Robin Hood's Bay: National Trust property. At the edge of the sea in Robin Hoods Bay village, there are hands on models to try and fascinating displays to browse. Find out what makes this part of the North Yorkshire Coast so special, from its distinctive geology and the impact of the elements, to local wildlife and the secret history of smuggling.

Saltburn Cliff Lift: Lower Promenade, Saltburn, TS6 9AR.

Saltburn Smugglers Heritage Centre: Saltburn Smugglers Heritate Centre, Old Saltburn, Saltburn-by-the-Sea, TS12 1HF.

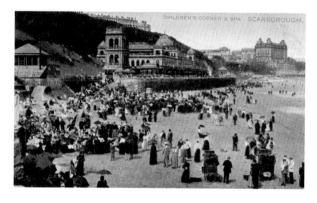

Children's Corner and Spa, Scarborough, early 1900s.

East Row and the bridge, Sandsend, from Gordon Home, *Yorkshire Coast and Moorland Scenes*, 1904.

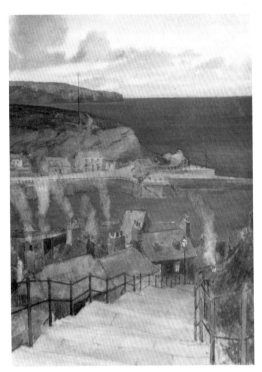

Right: Evening at Whitby, from Gordon Home, 1904, *Yorkshire Coast and Moorland Scenes.*

Below: North Yorkshire fishermen from George Walker's *The Costume of Yorkshire*, 1814.

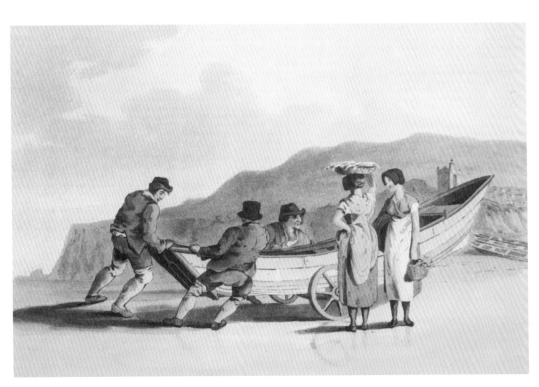

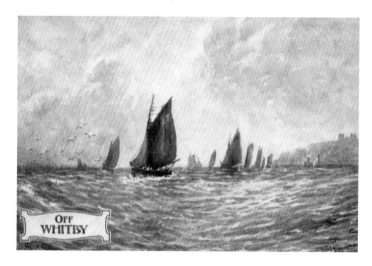

Off Whitby, early 1900s.

Sea Urchins, 1911.

Sunset over the harbour
piers at Whitby, 1970s.

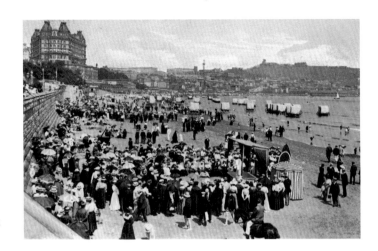

The Pierrots, Scarborough South Sands, early 1900s.

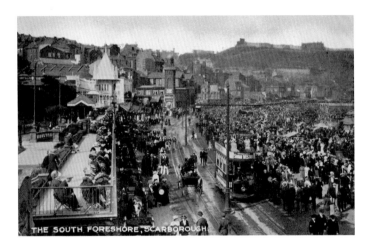

The south foreshore, Scarborough, 1914.

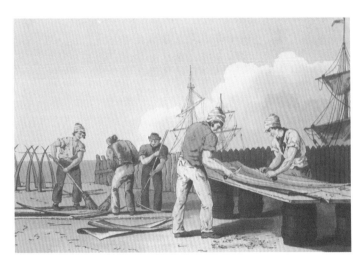

The whale-bone scrapers from George Walker's *The Costume of Yorkshire*, 1814.

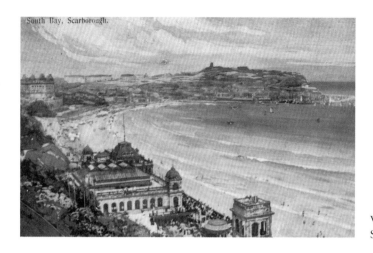

View of South Bay,
Scarborough, and Spa, 1907.

Whitby Tate Pier Hill,
early 1900s.

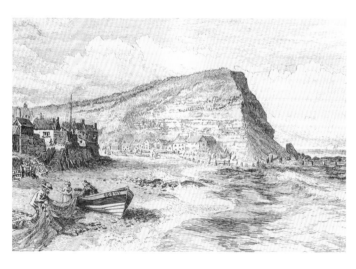

Staithes from Leyland, 1892.

Bibliography – Sources and Suggested Reading

Anon., *A Guide to All the Watering and Sea Bathing Places: Longman, Rees, Orme* (London: Brown and Green, 1842).

Anon., *A Guide to Historic Scarborough* (Scarborough: Scarborough Archaeological and Historical Society, 2003)

Barker, M., *The Golden Age of the Yorkshire Seaside* (Ilkey: Great Northern Books, 2002).

Boyes, M. & H. Chester, *Walks From Your Car: Bridlington and Scarborough* (Clapham, Lancs Dalesman Books, 1991).

Chapman, V., *Yorkshire Seaside Resorts and Harbours in Old Picture Postcards* (The Netherlands: European Library, The Netherlands, 1997).

Clegg, K., *Filey, a Select Resort* (Filey: K. Clegg, 1998).

Dykes, J., *Smuggling on the Yorkshire Coast* (Clapham, Lancs: The Dalesman Publishing Company Ltd, 1978).

Eccleston, J. & P. A. Eccleston, *History and Geology of Staithes* (Staithes: William Peter Eccleston BSc and Jean Eccleston LLB, Staithes, 1998).

Fairfax-Blake, J. & R. Fairfax-Blake, *The Spirit of Yorkshire* (London: B. T. Batsford Ltd, 1954).

Farnhill, B., *A History of Robin Hood's Bay* (Helmsley, North York Moors National Park, 1996).

Fletcher, J. S., *Nooks & Corners of Yorkshire* (London: Eveleigh Nash, 1910).

Gerrard, D. (ed.), *The Hidden Places of Yorkshire, Including the Yorkshire Dales* (Aldermaston, Berks: Travel Publishing Ltd).

Gough, S. W., *The Yorkshire Coast. The England That I Love*, No. 1. No publisher given.

Hammond, R. J. W. (ed.), *The Yorkshire Coast* (London and Melbourne: Ward, Lock & Co. Ltd, London and Melbourne, 1966).

Harland, O., *Yorkshire North Riding* (London: Robert Hale Ltd, 1951).

Harrison, B.J. D. & G. Dixon (eds), *Guisborough Before 1900* (Guiseley, Yorks: M. T. D. Rigg Publications, 1994).

Hatcher, J., *Exploring England's Heritage. Yorkshire to Humberside* (London: English Heritage, HMSO, 1994).

Heavisides, M., *Rambles in Cleveland and Peeps Into the Dales on Foot, Cycle and Rail* (Stockton-on-Tees: Heavisides & Son, 1901).

Hemingway, J.E., V. Wilson, & C. W. Wright, *No. 34: Geology of the Yorkshire Coast* (Colchester: Benham & Co. Ltd, 1968).

Home, G., *Yorkshire Coast & Moorland Scenes* (London: Adam & Charles Black, 1904).

Home, G., *Yorkshire* (London: Black, 1908).

Home, G., *Yorkshire Coast & Moorland* (London: Black, 1915).

King, C. A. M., *The Scarborough District. British Landscapes Through Maps, Vol. 7* (Sheffield: The Geographical Association, 1965)

Laughton, T., *Royal Hotel. The Story of a Family Enterprise* (Scarborough: Royal Hotel, 1967).

Leyland, J., *The Yorkshire Coast and the Cleveland Hills and Dales* (London: Seeley & Co. Ltd, 1892).

Lidster, J. R., *Robin Hood's Bay As It Was: A Pictorial History* (Nelson, Lancs: Hendon Publishing Co., 1981).

Lord, G., *Scarborough's Floral Heritage: Over 100 Years of Parks and Gardens in Britain's First Resort* (Scarborough: Scarborough Borough Council, 1984).

Markham, L., *Clarty Strands: A Walking Tour of the Yorkshire Coast* (Beverley: Hutton Press Ltd, 1990).

Markham, L., *Discovering Yorkshire's History* (Barnsley: Wharncliffe Books, 2004).

Miller, I., *Steeped In History: The Alum Industry of North-East Yorkshire* (2002).

Morris, J. E., *The North Riding of Yorkshire.* Third edition revised. (London: Methuen & Co., 1931).

Radford, G., *Rambles by Yorkshire Rivers* (Leeds: Richard Jackson, 1885).

Rennison, E., *North Yorkshire Off The Beaten Track* (Newbury, Berks Countryside Books, 2003).

Robinson, R., *A History of the Yorkshire Coast Fishing Industry 1780–1914* (Hull: Hull University Press, 1987).

Smith, *Smuggling in Yorkshire 1700–1850* (Newbury, Berks: Countryside Books, 1994).

Taylor, F. D., *Walks And Motor Tours Around Scarborough* (Scarborough: H. O. Taylor Ltd, 1957).

Turton, R. B., *The Alum Farm Together with a History of the Origin Development and Eventual Decline of the Alum Trade in North-East Yorkshire* (Whitby: Horne & Son Ltd, 1938).

Walcott, M. E. C., *Guide to the Coasts of Lincolnshire & Yorkshire* (London: Edward Stanford, 1861).

Walker, G., *The Costume of Yorkshire* (London: Longman, Hurst, Orme & Brown, 1814).

Whitworth, A. (ed), *Aspects of the Yorkshire Coast: Discovering Local History* (Barnsley: Wharncliffe Publishing, 1814).

Whitworth, A. (ed.), *Aspects of the Yorkshire Coast: Discovering Local History 2* (Barnsley: Wharncliffe Publishing).

Williamson, P., *Castle Walks in Yorkshire* (Lancaster: Palatine Books, 2006).